IMAGES
of America

PORT RICHMOND

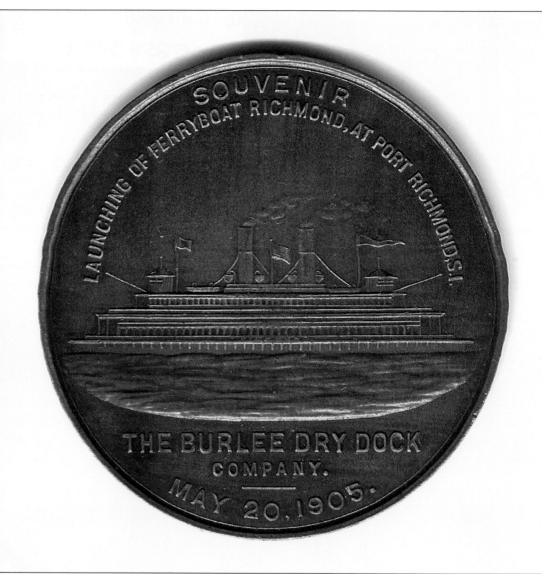

On May 20, 1905, New York mayor George McClellen traveled to Port Richmond for the launching of the ferryboat *Richmond*, built at Burlee Dry Dock. This was one of the first five municipal borough-class ferries. Richmond County, founded in 1683, was named for Charles Lennox (1672–1723), the Duke of Richmond, son of King Charles II. This medal is one of 60,000 material objects in the collection of the Staten Island Historical Society. (Staten Island Historical Society.)

On the cover: Known as the "Times Square of Staten Island," Port Richmond housed three of the island's 20 movie theaters. The Palace Theater, built at 108 Richmond Avenue in 1915, held 980 seats. Up and down "the Avenue" were retail shops and eateries. Richmond Dry Goods was a place to go for women's hats and clothing. Next door (not pictured) was Dansky's, owned by Russian Jewish immigrant Sam Dansky, which sold work clothes and boots. (Staten Island Historical Society.)

IMAGES
of America

PORT RICHMOND

Phillip Papas and Lori R. Weintrob

ARCADIA
PUBLISHING

Published by Arcadia Publishing
Charleston, South Carolina

Printed in the United States of America

Library of Congress Control Number: 2009930551

For all general information contact Arcadia Publishing at:
Telephone 843-853-2070
Fax 843-853-0044
E-mail sales@arcadiapublishing.com
For customer service and orders:
Toll-Free 1-888-313-2665

Visit us on the Internet at www.arcadiapublishing.com

This book is dedicated to the residents, merchants, and workers of Port Richmond, past and present, like Phillip Papas (seen here), and particularly to each new wave of immigrants since 1661, whose struggles, joys, and triumphs have defined this community. (Nicholas and Elisabeth Papas.)

CONTENTS

Acknowledgments

Next door to the Ritz Theater in the 1950s, Phillip Papas, an immigrant from Thrace, Greece, crafted leather soles in his shoe repair shop. His grandson, one of the coauthors, grew up buying shoes in Tirone's, riding his bicycle on Clinton Place, and enjoying chocolate cats from Supreme Chocolates with his godparents. The other author, grandchild of Russian immigrants, first went to Port Richmond in 2003 to organize a project with El Centro de Hospitalidad for after-school tutoring by Wagner College students. Pres. Richard Guarasci and provost Devorah A. Lieberman have made a long-term commitment to this neighborhood. In 2009, Daniel Coates of Make the Road approached the history department to write lessons on Port Richmond's immigration history for English as a second language classes. What emerged was a joint project—historical and civic-minded—about the meaning of community on Staten Island.

Our undertaking was encouraged by the enthusiasm of Joe and Lou Tirone, Harold and Etta Garber, Ann Merlino, Bertha Lee, Cheryl Criaris Bontales, and many others who donated their time, photographs, and stories. We thank the Staten Island Historical Society, notably Ed Wiseman, Carlotta De Fillo, Sarah Clark, and Maxine Friedman, for helping us locate photographs and material objects. We are grateful to Claire Regan and Brian Laline for permission to use the photographs of the *Staten Island Advance* and to Susan Glancy and chief librarian Melinda Gottlieb for assistance in locating them, Northfield Community Local Development Corporation (LDC) for its archival materials, and Erin Vosgien for her editorial assistance. Guidance with research was also provided by Patricia Salmon and Cara Delatte at the Staten Island Museum, whose director Elizabeth Egbert was generous in granting permission to use its materials. We also thank Tom Flanagan for his sketches and Jim Whitford for his family history. We thank Barnett Shepherd, who offered to review our chapter on architecture. A Learn and Serve America grant to Wagner College provided partial funding for this book. Debra Killen, assistant secretary to the history department, brought patience (and humor) to the hours needed to scan and lay out these images.

We appreciate the love and support our families have given us during this project. A special thanks to Lori's daughter Joelle, now a fan of Ralph's Ices, for her patience during the writing of this book.

INTRODUCTION

Known as "Mersereau's Ferry," a "model village," a "league of nations," and the "Times Square of Staten Island," Port Richmond has a rich and complex past.

Following the American Revolution, John Mersereau, a leading patriot of French descent, bought the ferry to New Jersey. So critical was this service that the town was renamed Mersereau's Ferry. Another patriot, Phebe Hand, a young woman from New Jersey of British descent, used money from a Continental bond she cashed out to purchase the waterfront home where, in 1794, she gave birth to Cornelius Vanderbilt. Port Richmond, a popular stagecoach stop, was part of the township of Northfield, which included Graniteville, Bull's Head, and Mariners Harbor.

From 1866 to 1898, Port Richmond became a self-governing entity, a "model village" with "well-paved sidewalks," elegant homes, and "substantial business blocks." Its boundaries, which included Elm Park, went from Jewett Avenue to Harbor Road in Mariners Harbor. One of Port Richmond's prominent citizens, George W. Jewett, an owner of John Jewett and Sons White Lead Company, employed an Irish nanny and workers, immigrants who fled Ireland for greater economic opportunities.

Shipbuilding, oystering, and manufacturing drew a variety of immigrants to the area. "There are fair haired Scandinavians, Scotch, English, Irish, Italians, Greek and Negro children, and perhaps other nationalities which I have not noticed," wrote one librarian in 1937. The neighborhood was identified as a "league of nations." Land for the Port Richmond library was purchased from a Cuban landowner. Italian mothers took English lessons with the Church of St. Adalbert's Msgr. Joseph "Father Joe" Brzoziewski.

By the 1940s, with three vibrant movie theaters, restaurants, and exclusive shops, Port Richmond was the "Times Square of Staten Island." Merchants took pride in showcasing "the Avenue" by dressing it up with Christmas lights and sponsoring Flag Day parades.

The closing of the Palace Theater in 1951 and the elimination of passenger service on the Staten Island Railway North Shore line in 1953 signaled a gradual economic decline. The 1958 opening of the Forest Avenue Shoppers Town and later the mall escalated the downturn. In 1983, Richmond Avenue was renamed Port Richmond Avenue as part of an effort to revitalize the neighborhood. Beginning in the 1990s, cooperation between the Port Richmond Board of Trade, the Northfield Community Local Development Corporation, Project Hospitality, merchants, and residents, including immigrants from Mexico, the Middle East, and the Caribbean, have brought renewed hope for "the forgotten neighborhood" in "the forgotten borough."

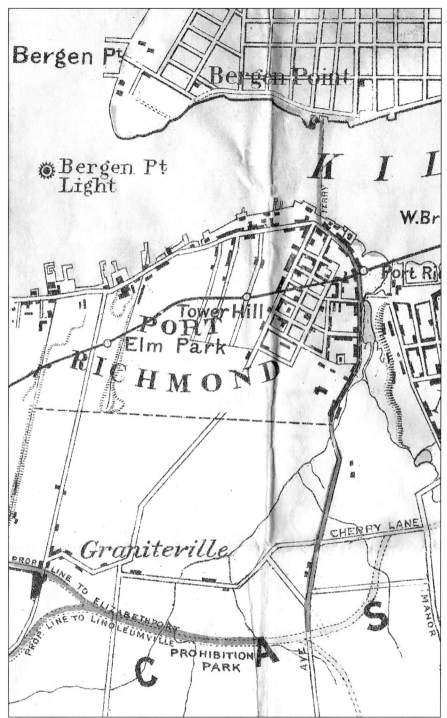

This 1895 map situates the town of Port Richmond, a self-governed "model village" from 1866 to 1898, as a critical transportation hub across from Bayonne, New Jersey. During this time, its boundaries extended farther west along the Kill Van Kull than today to include Elm Park and parts of Mariners Harbor up to Harbor Road. (Staten Island Historical Society.)

One

TRANSPORTATION

Because of its accessibility to points along the East Coast from Philadelphia to Manhattan, whether by horseback, stagecoach, ferry, trolley, or rail, the area now known as Port Richmond developed as a vibrant commercial center. Native American Lenni-Lenapes, notably the Hackensack tribe, are believed to have used this area as one of their points of departure from the island.

Several ferries operated from Port Richmond, which, in the early years, was variously called Decker's, Dacosta's, Ryers', Hilleker's, or Mersereau's Ferry. After 1823, steam ferries traveled from Port Richmond to Whitehall slip in Manhattan. Only seven years earlier, in 1817, steam ferries were introduced on Staten Island by Daniel Tompkins and Cornelius Vanderbilt, the latter born in Port Richmond.

In the 1830s, horse boats carried passengers across the Kill Van Kull. The galloping horses on the treadmill, which powered the boat, were a great attraction. Yet, as resident James Hillyer recalled, when the tides were strong, the operator whipped the horses to prevent the boat from drifting toward the bay. As the ferries approached the wharf at Port Richmond, they would ring a bell to alert residents of arriving guests.

Port Richmond was an important stop on the stagecoach route between Manhattan and Philadelphia. The last stagecoach route on Staten Island ran between Port Richmond and Linoleumville (now Travis) in the early 1900s.

The horse-drawn vehicles gave way to trolleys. In 1892, the electric trolley arrived on Staten Island, making its initial run from Port Richmond to Prohibition Park (now Westerleigh). In 1913, 5 of the island's 11 trolley lines went through Port Richmond, linking the town to St. George, Bull's Head, the Elizabethport Ferry at today's Holland Hook, Midland Beach, Concord, and Silver Lake.

By the early 1930s, the trolleys were in turn eclipsed by railroads and buses. In 1931, the proliferation of automobiles and trucks led to the building of the Bayonne Bridge. The Staten Island Railway North Shore line, which opened in the late 1880s, linked Port Richmond to St. George until passenger service was discontinued in 1953. The last ferry ran from Port Richmond to Bayonne in 1961.

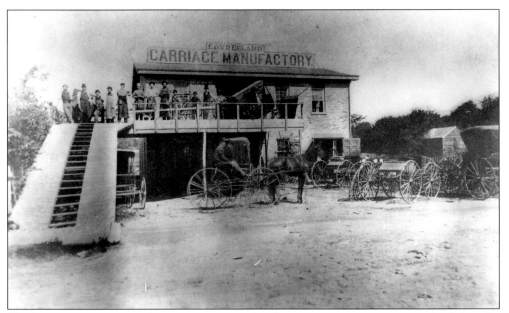

The horse-drawn stagecoach was a mainstay of early transportation on Staten Island. On the first floor of E. O. Vreeland Carriage Manufactory was the construction shop. After the carriages were built, they were pushed up the ramp to the second-floor paint shop. The men in this image are employees. (Staten Island Historical Society.)

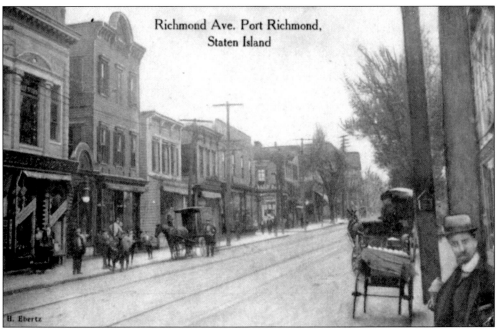

In the 1890s, the shops along Richmond Avenue attracted wealthy families who had their own private carriages, cartmen loading wares for transport or delivery, and passengers on the stagecoach. The Bergen Point Ferry increased commercial and commuter traffic through the town. (Staten Island Museum.)

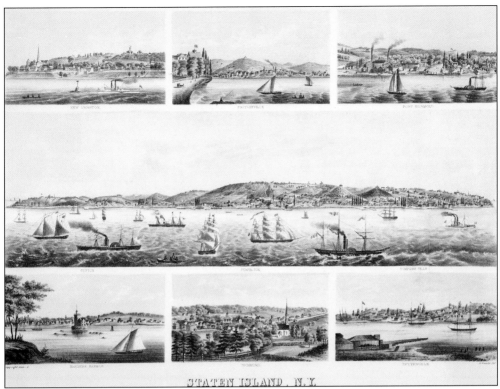

STATEN ISLAND, N.Y.

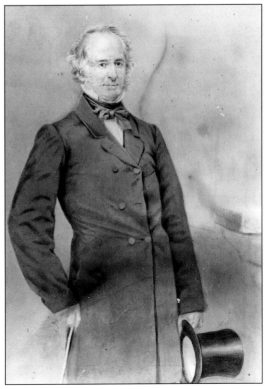

In 1715, Jacob Van Derbilt and Nelje Denyse moved to a Staten Island farm and left the Dutch Reformed Church to become Moravians. At a local shipyard, they helped the New Dorp Moravians build a vessel to transport hundreds of persecuted Moravians to America from Europe. Their grandson Cornelius (born in 1764) moved to Port Richmond in 1780 and, seven years later, married Phebe Hand of British descent. In 1791, Phebe cashed out a Continental bond to purchase a small farmhouse in Port Richmond overlooking the Kill Van Kull. Cornelius was paid to transport goods to Manhattan in his periauger. In 1794, Cornelius and Phebe's fourth son, Cornelius, was born, who grew up to make a vast fortune in ferries and railroads. The family moved to a larger house in Stapleton. The lithograph above shows brigantines, schooners, square-riggers, and sloops in the waters off Staten Island, a scene of international commerce that may have inspired young Cornelius. (Staten Island Historical Society.)

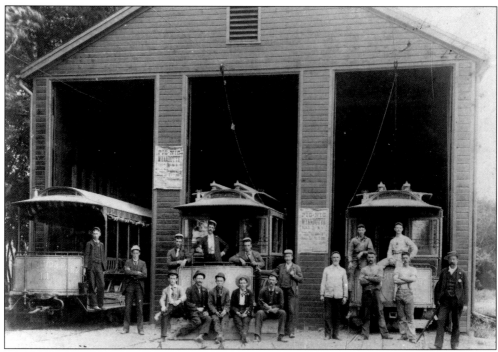

The first electric trolley car on Staten Island ran in 1892 from Port Richmond Square to Prohibition Park (now Westerleigh). The trolley, with overhead wires and a long, flexible arm, was affectionately known as "Red Mike" and ran along Richmond Terrace and Jewett Avenue. In 1896, the Staten Island Midland Electric Railroad Company ran its first electric car from Port Richmond to Richmondtown, then the civic center of the county. During 1920 and 1921, strikes by trolley workers led to fare increases from 5¢ to 8¢. (Above, Staten Island Historical Society; below, Staten Island Museum.)

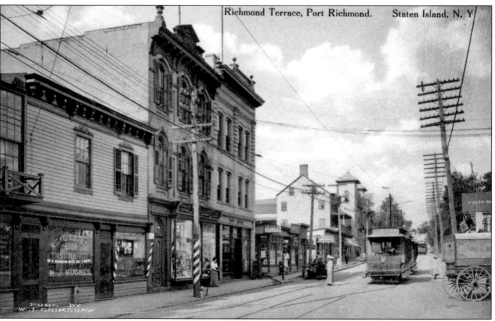

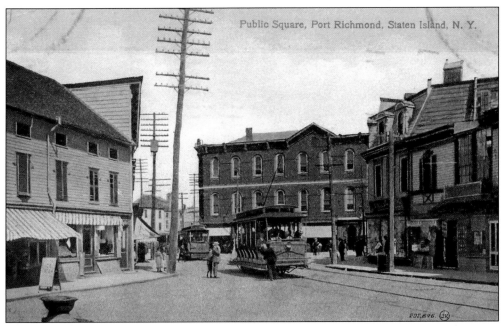

In this 1916 postcard, trolleys move through the public square at Port Richmond. The town became a transfer point for streetcars and later for bus lines, encouraging the growth of a prosperous commercial center. (Staten Island Museum.)

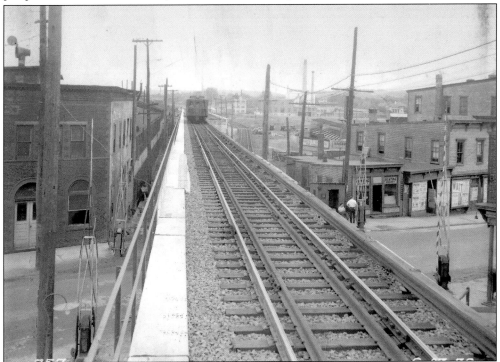

The Staten Island Railway North Shore line, which ran from the late 1880s to 1953, stopped at both Port Richmond Square to access the main shopping area and Tower Hill near Elm Park. (Staten Island Historical Society.)

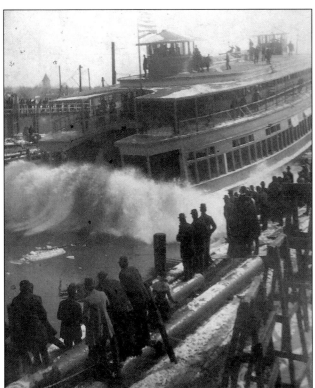

Burlee Dry Dock in Port Richmond and Van Clief's Dry Dock were among the dozens of shipyards on the island after 1820. The launching of the ferryboat *Chicago* from Burlee Dry Dock drew admiring spectators. Burlee Dry Dock started a shipyard for the construction of wooden vessels in 1906. (Staten Island Historical Society.)

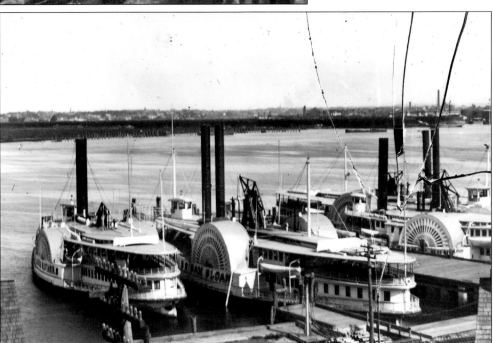

Starin Shipyard was located at the foot of Bodine Street near the dividing line between West New Brighton and Port Richmond. This image of picturesque side-wheeler steamboats was taken around 1908. (Staten Island Historical Society.)

One of the longest and most beautiful steel arches in the world, the Bayonne Bridge soars 226 feet above the Kill Van Kull. Swiss-born Othmar Ammann, chief engineer of the Port Authority of New York and New Jersey, who was also responsible for the Verrazano-Narrows Bridge and the George Washington Bridge, designed the $13 million, 8,640-foot-long structure, which opened on November 15, 1931. A mural by Frederick Starr, a Works Progress Administration painter, captured this scene. It now hangs in the Staten Island Borough Hall. (Lori R. Weintrob.)

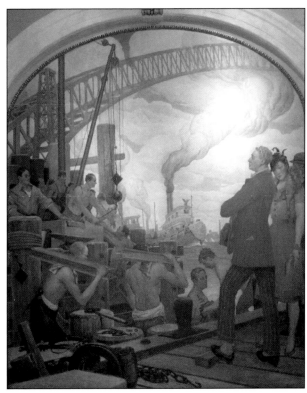

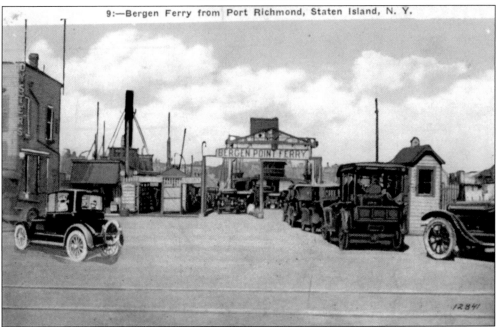

By the 1920s, the automobile had replaced the horse-drawn carriage for passenger transportation, while trucks replaced the horse-drawn cart for moving freight. Automobiles and trucks waited in line to board the ferry to Bergen Point (now Bayonne). The trolley continued to run along Port Richmond Avenue until the 1930s. (Staten Island Museum.)

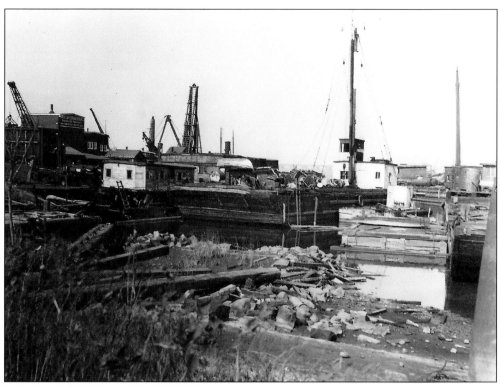

By the late 1940s, parts of the once-vibrant Port Richmond waterfront became a maritime graveyard where ships were salvaged, as seen above. However, through the eyes of a Port Richmond High School artist, Joseph Tyszka in 1940, bucolic elements remained. The image at left shows the continued role of tugboats and suggests the potential of the Port Richmond waterfront for future development. Since 2001, the North Shore Waterfront Conservancy, presided by Beryl Thurman, has worked to promote access to and revitalization of the waterfront. (Staten Island Historical Society.)

Two

BUSINESS

By 1940, Richmond Avenue became known as the "Fifth Avenue of Staten Island." Port Richmond buzzed with commercial activity, and retail stores lined both sides of the avenue. For many Staten Islanders, time was spent strolling along Richmond Avenue, shopping for shoes at Tirone's or buying a dress at Garber Brothers or Lobel's.

Port Richmond had been an important commercial hub since Colonial times. Ferry and stagecoach traffic through Port Richmond led to the establishment of several inns and taverns, such as the St. James. Mills, such as Bodine's Grist Mill, were important to Staten Island's preindustrial economy. In 1888, Conklin's Planing Mill became Farrell Lumber. Mills and the traditional artisanal trades were eclipsed by large-scale industrial manufacturing in the mid-1800s with the arrival of Barrett, Nephews and Company, a large cloth-dyeing plant, and John Jewett and Sons White Lead Company, which manufactured lead-based paint. The maritime trades of fishing, whaling, oyster cultivation, commerce, and navigation were also major employers until the 1920s. Ship construction and repair brought jobs but also pollution. These firms employed hundreds of skilled and unskilled workers from Britain, Ireland, Germany, and Scandinavia.

Into the 21st century, some manufacturing remained, such as Farrell Lumber and Staten Island Plate Glass Company. But with the building of shopping centers and, in 1973, the Staten Island Mall, commercial activity declined. However, a core of longtime businesses like Wexler's, Richmond Chandelier, Tirone's, Nat's Men Shop, and Oven Bake remained strong. Today "the Avenue" is proud of the diversity of businesses, such as graphic design shops, ethnic restaurants, a cell phone distributor, and a range of community service providers, which have revitalized the area.

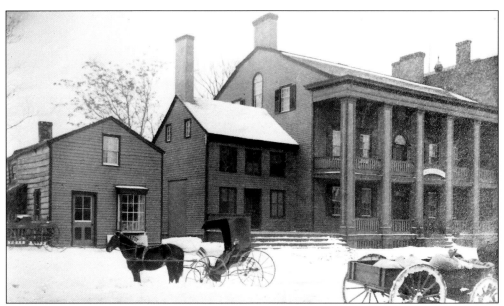

Aaron Burr tied with Thomas Jefferson in electoral college votes during the 1800 election for president, but Congress decided in favor of the latter. While serving as vice president, Burr mortally wounded Alexander Hamilton, the former secretary of the treasury, in a pistol duel in Weehawken, New Jersey, in 1804. At age 70, on September 14, 1836, Burr died at the St. James Hotel, built a half century earlier. In 1949, the New York State Supreme Court ordered it demolished. (Staten Island Historical Society.)

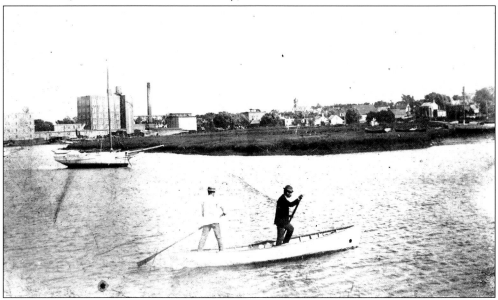

"Port Richmond is dear to the lovers of oysters and these delicious bivalves, the delight of city epicures, have made fortunes for many of the dealers," reported an 1857 newspaper. Once plentiful, oyster beds of the Kill Van Kull enjoyed by Native Americans, European settlers, and enslaved Africans were nearly depleted by 1810. Thereafter, oystering became more sophisticated. Oyster boats left every fall for Virginia to gather tiny larval "set" oysters to plant and cultivate. (Staten Island Historical Society.)

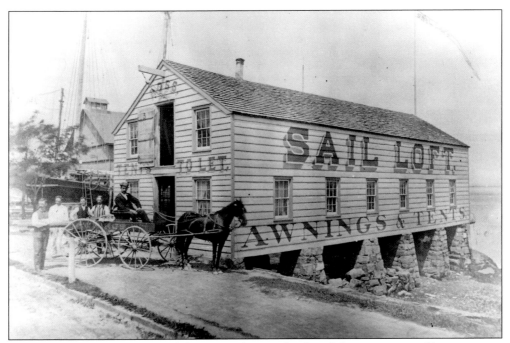

By the 1840s, vibrant fishing and shipping industries developed that were serviced by enterprises such as sail lofts. In addition to nautical sails, sail lofts also manufactured building awnings and tents. George Ross's sail loft, shown here in the 1890s, was located on Richmond Terrace and Lafayette Avenue (now Treadwell Avenue). (Staten Island Historical Society.)

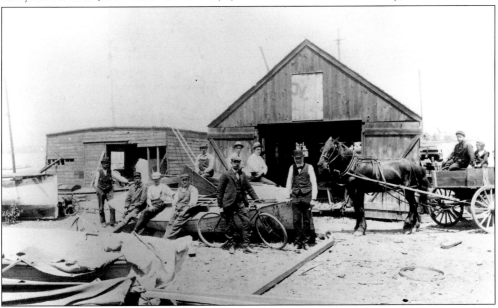

The road along the Kill Van Kull west of Port Richmond was "thickly inhabited by persons engaged in boating, bathing or oyster trade," reported Samuel Ackerley in 1842. Boatyards produced sloops and schooners of various sizes for industry or recreation by the late 19th century. The wealthy oystermen of Nicholas Avenue utilized these boatyards, which depended on labor from workers in neighboring communities. (Staten Island Historical Society.)

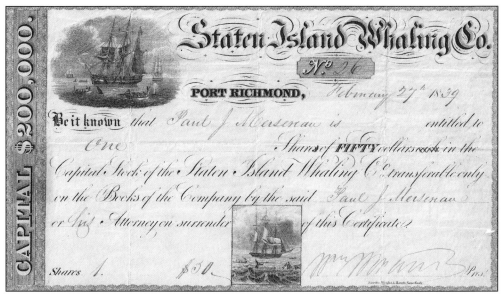

From 1838 to 1842, the Staten Island Whaling Company operated the bark (a type of boat) *White Oak* and a whale oil–processing plant in Port Richmond. (Staten Island Historical Society.)

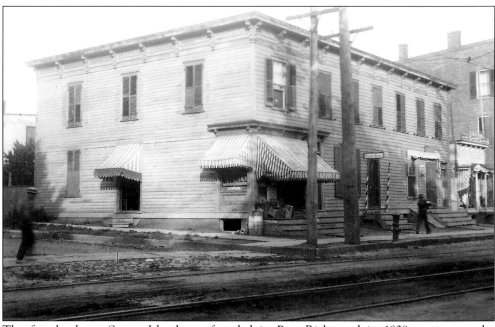

The first bank on Staten Island was founded in Port Richmond in 1838 to support the whaling company. Bank president Richard D. Littell was a lawyer and judge from New Jersey. Among the board of directors were Eder Houghwout, Jacob Bodine, and Dr. John Harrison, Littell's son-in-law. Port Richmond residents Charles Ingalls, Theodore Spratt, and H. Eugene Alexander also founded the First National Bank of Staten Island (1886–1905). (Staten Island Historical Society.)

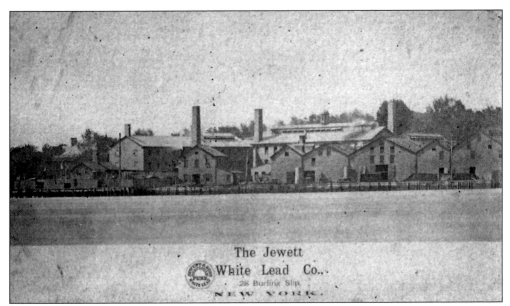

John Jewett and Sons White Lead Company, begun in 1842 on the site of the whaling company, produced 3,500 tons of white lead annually for paint. One hundred employees worked on the three acres of grounds. The eldest son, George W. Jewett, became wealthier than brothers John Jr. and Charles. Recently the Environmental Protection Agency found extremely high lead levels in the soil on the site at 2000 Richmond Terrace. (Staten Island Historical Society.)

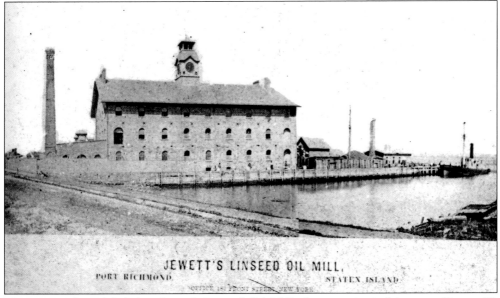

This postcard, mislabeled as Jewett's Linseed Oil Mill after its principal investor George W. Jewett, was actually the J. A. Dean and Company Linseed Oil Mill. Located on Front Street along the Kill Van Kull with its own docking facility, the company had 60 employees and produced 500,000 gallons of standard linseed oil annually. A public clock was mounted on the main building. (Staten Island Historical Society.)

In the image above is Bodine's Grist Mill, at the boundary of Port Richmond and West Brighton. Mills were eventually displaced by large factories. In 1851, Col. Nathan Barrett built an eight-acre cloth-dyeing plant, Barrett, Nephews and Company's Fancy Dyeing Establishment, shown below, on Cherry Lane (now Forest Avenue). Barrett left his position as superintendent of the New York Dyeing and Printing Establishment in Factoryville (now West Brighton), an enterprise founded by his family, who came from Massachusetts in 1820. The steam-powered facility on Cherry Lane and its branch offices in Boston and Philadelphia employed over 200 workers. In 1895, the two competing companies merged, and the operations returned to the original location in Factoryville. In 1958, the Forest Avenue Shoppers Town was created at the Cherry Lane site. (Above, Staten Island Museum; below, Staten Island Historical Society.)

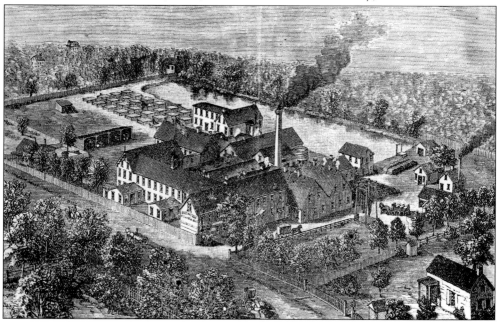

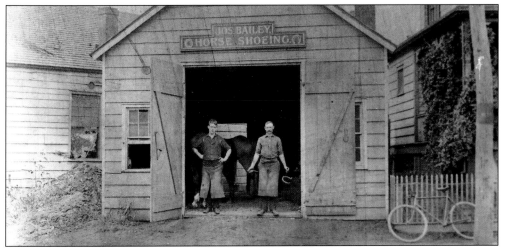

Blacksmiths such as Joseph Bailey, whose shop was located on the corner of Post and Jewett Avenues, played a vital role in ensuring that the horses pulling the stagecoaches were well shod. The bicycle leaning against the fence suggests that this artisan rode to work. Eight blacksmiths are listed in the 1898 business directory for Port Richmond. (Staten Island Historical Society.)

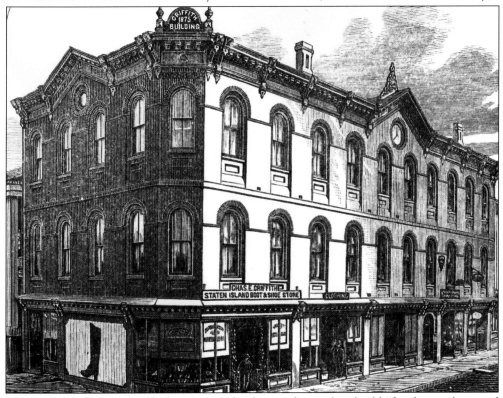

Charles E. Griffith, originally from Long Island, manufactured and sold "fine boots, shoes and rubbers" at the corner of Richmond Avenue and Shore Road (now Richmond Terrace). While specializing in "ladies and gentlemen's boots," he also sold children's rubber and oil raincoats and horse covers and supplied shoemakers with leather and findings. An ornate cornice with spiral pendants sits atop this brick structure. (Staten Island Historical Society.)

STATEN ISLAND
CHAMBER
OF COMMERCE

ACKNOWLEDGES WITH APPRECIATION THE SUPPORT OF

H.S. Farrell Inc.

a valued member for 66 years

As an organization dedicated to the guidance, support and interests of our members, we acknowledge with gratitude the contributions you have made to the economic life of this borough as we strive to fulfill our mission: *"To improve the economic climate and enhance business opportunities on Staten Island."*

We are grateful for your continuing membership and proud to have been a partner in the growth and prosperity of your business.

June 25, 1996

For over a century, Farrell Lumber provided chestnut, white pine, and other woods purchased from as far away as China and California to craft the moldings and doors in thousands of homes in New York and New Jersey. They provided over 100,000 feet of lumber for the Verrazano-Narrows Bridge and during World War II contributed wood for barrels used to ship goods overseas. In 1900, Harry S. Farrell arrived on Staten Island from New Jersey and took over Conklin Mills, founded in 1888. After Farrell's death2, his wife, Marion, ran the business for almost 50 years. Her sons Don and Bob became partners in 1968 and had 50 employees. Bob has served on numerous civic organizations, including the Richmond County Savings Bank and Wagner College Board of Trustees. In 2000, Farrell Lumber earned the Lew Miller Award. (Above, Bob Farrell; below, Northfield Community LDC.)

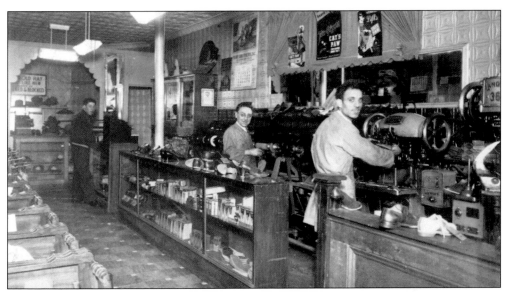

Arriving from Sicily in 1928, shoemaker Carmelo Tirone moved to Faber Street after a brief period in Manhattan. He opened a shoe repair and retail store near Port Richmond Square and had five children with his wife of 60 years. During World War II, the rationing of leather generated stacks of shoes for repair. The 1943 image above depicts Tirone and his son Sal at work; in the background is Joe Mantia. In 1949, Tirone made his three sons, Sal, Joe, and Lou, partners. Seen below on opening day in 1949, the family stands at the store's new location, which has been a favorite stop for buying shoes for communions and nurses' uniforms or sneakers ever since. Joe sang Frank Sinatra songs at the Catholic Youth Organization (CYO) in his youth and served as president of the Port Richmond Board of Trade for 25 years. (Joe and Lou Tirone.)

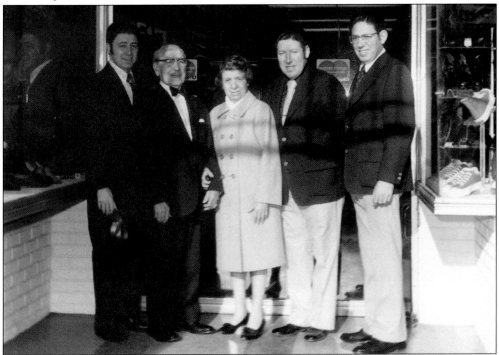

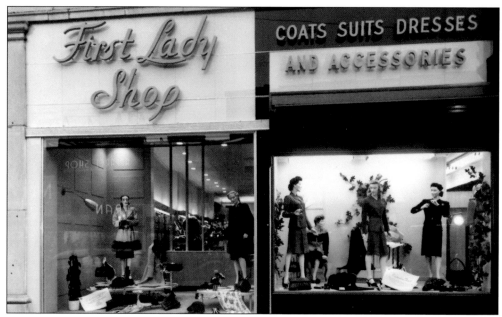

In 1916, Louis, David, and Paul Garber began peddling on Staten Island. Each took a different route with wares on their backs. They built a loyal customer base by selling men's and boys' clothing on credit and soon opened a warehouse on Richmond Terrace, which became a retail outlet. In 1924, their first store at 163 Richmond Avenue opened. By 1946, they also sold ladies' clothing. (Harold and Etta Garber.)

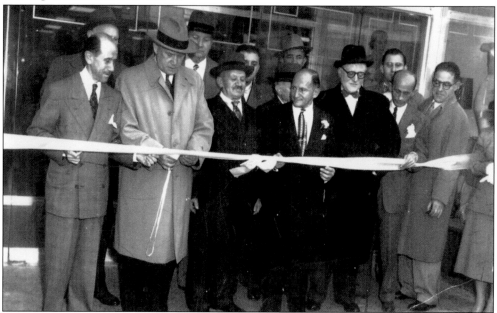

In 1951, the Garber brothers opened a new store at 281 Richmond Avenue, with blessings from Rabbi Benjamin B. Wykansky of Temple Emanu-El. From left to right are (first row) David Garber, Borough Pres. Cornelius Hall, Abraham Garber (the brothers' father), Louis Garber, Wykansky, and Paul Garber. Their second store in Stapleton, which specialized in navy uniforms during World War II, was thriving but closed in 1958. (Harold and Etta Garber.)

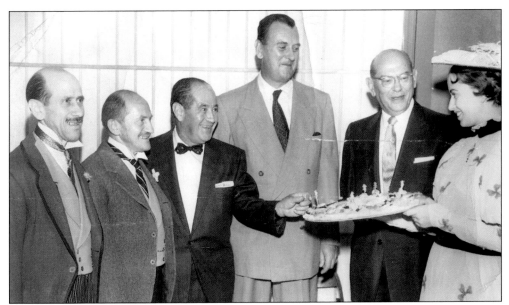

In 1959, at its 40th anniversary celebration, Garber Brothers boasted of carrying "3,000 fashion items that Staten Islanders want." The father-son tradition in the family enterprise was exemplified by the entry of a new generation: Paul's son Murray, Louis's son Harold, and David's son Charles. Garber's in New Dorp opened in 1965, a year after the brothers sold the business to the Goldring Corporation. Harold Garber stayed on as general manager for a few years. (Harold and Etta Garber.)

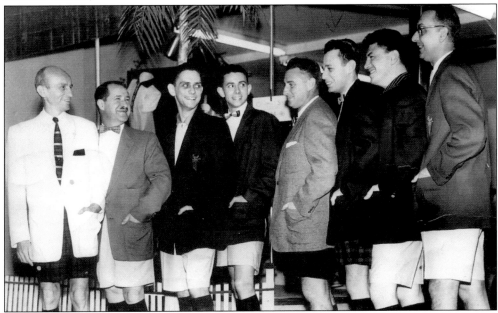

Entertaining customers was one of Garber Brothers' strategies, as in this 1957 image. Broadway actors reenacted scenes from plays such as *The Pajama Game* on a stage above the jewelry department. Celebrity Toni Randazzo and sports stars like Ed Kranepool made shopping fun. Garber Brothers sponsored the Battle of the Bands at the Ritz Theater. Youngsters were drawn in by pie-eating contests, pony rides, and rabbit races through the store. (Harold and Etta Garber.)

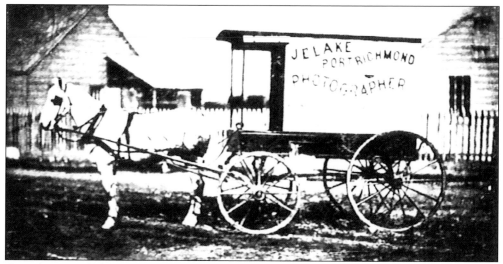

One of Staten Island's well-known photographers was John E. Lake. From 1870 to 1890, his studio was located on Richmond Terrace. Going around the island on horse and wagon, he captured many local subjects in portraits or landscape scenes. (Staten Island Historical Society.)

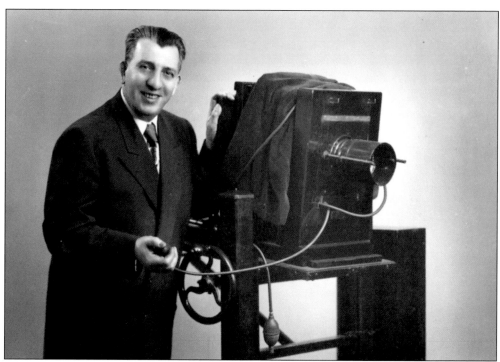

After his service in World War I, Gioacchino "John" Merlino studied photography on the GI Bill at City College. In 1927, he went to Paris to receive a gold medal at an international photography competition. In 1930, he relocated his studio from Grand Street in Little Italy to Richmond Avenue after a brief return to Naples, where his studio was located in the galleria. (Ann Merlino.)

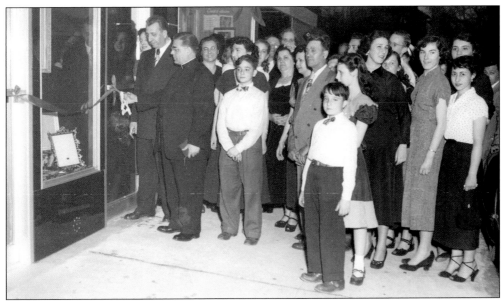

In 1952, the store was enlarged and expanded to accommodate more business and a growing family of 12 children, who lived in the home adjacent to the studio. In America, Merlino's dreams came true. In 1905, his father came to New York from San Antimo to work but died on the boat returning to Italy. The orphaned 17-year-old, who aspired to write, came in 1910 to live on Bennett Street, Port Richmond, with a family from his hometown. He published songs and poems in *La Follia di New York* in Neapolitan dialect. He made wine in his backyard. In 1948, Mayor William O'Dwyer appointed him to the committee for the 50th anniversary of the consolidation of New York. The eldest daughter, Ida, has worked in the studio continuously since its 1930 opening. Many of her siblings have also worked in the business and now third-generation family members continue the tradition. (Ann Merlino.)

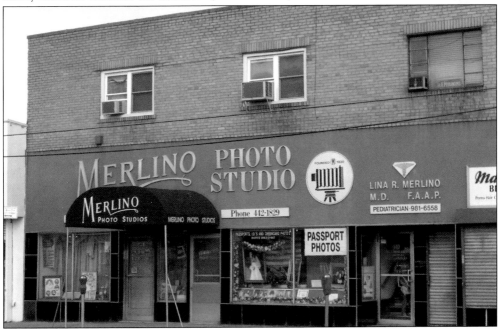

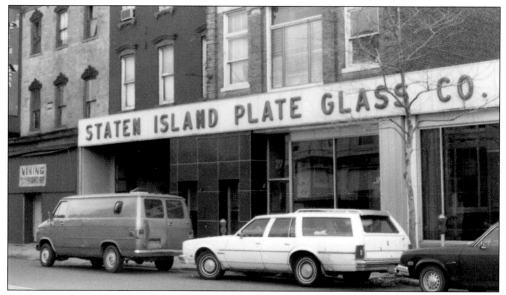

For the 100th anniversary of the Statue of Liberty in 1986, Staten Island Plate Glass Company provided materials for the staircase and elevator. According to Irwin Steinman, his grandfather Reuben, a watchmaker, first came from Latvia to Queens in 1914 then moved to the "countryside" of Port Richmond for fresh air when his son Charles got diphtheria. In 1926, the Staten Island Plate Glass Company began on Richmond Terrace then relocated in 1936 to Richmond Avenue and remained open until 2005. (Northfield Community LDC.)

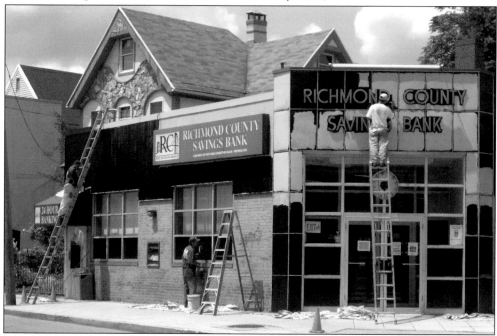

Richmond County Savings Bank has been a fixture on the corner of Richmond Avenue and Charles Avenue for decades. Its art deco facade was refurbished in June 2009. Several banks, including Staten Island Savings Bank, Northfield Savings, and Westerleigh Savings, have been located in Port Richmond. (Lori R. Weintrob.)

Three

CIVIC AND POLITICAL LIFE

Although George Washington famously sailed through the Kill Van Kull to go to his 1789 inauguration, the first American president to come to Port Richmond was Andrew Jackson. After visiting Elizabethtown, New Jersey, in 1833, Jackson was met at Mersereau's Ferry by local business and religious elites, including Col. Nathan Barrett and Rev. Peter J. Van Pelt, who escorted him through New York Harbor to Castle Clinton. About a century later in 1936, Pres. Franklin D. Roosevelt drove over the newly built Bayonne Bridge and through Port Richmond.

As the franchise expanded and the laboring population grew, political divisions became apparent. In 1813, only 10 percent of the residents of Staten Island were eligible to vote. By 1846, the new state constitution gave all male citizens over 21 the vote. Many factory workers voted for Democrats, but there were fewer of these in Port Richmond than in other Richmond County villages (like Factoryville or Linoleumville). The township of Northfield had a small Republican coalition, which supported the abolition of slavery, women's suffrage, and prohibition. Republican writer George William Curtis, namesake of Curtis High School in St. George, organized speeches in Park Baptist Church. Led by men such as police commissioner Garrett P. Wright, the Know-Nothing Party, which opposed new immigrants, notably Catholics, gained 216 votes against 212 for Democrats and 28 for Republicans in 1856.

Port Richmond became an independent village in 1866. Its final president before consolidation in 1898 was Frank Foggin, a Republican. Anning S. Prall, John M. Braisted, and John Lavelle, all Democrats, were important politicians who grew up in Port Richmond. In the civil rights era, the Staten Island office of the Congress of Racial Equality (CORE) opened on Richmond Terrace and Jewett Avenue. The town has benefited from bipartisan initiatives.

Local civic and business organizations—women's clubs, Masonic lodges, and youth groups—have worked to promote the neighborhood and address social concerns. For example, in the 1990s, Northfield Community Local Development Corporation (LDC) and the Port Richmond Board of Trade's Project Turnaround used Housing and Urban Development (HUD) funds secured by Congresswoman Susan Molinari to clean up graffiti, hire a security patrol, install new pedestrian lighting, and alleviate drugs and prostitution. The actions of Northfield Community LDC and other not-for-profits like Camelot and Project Hospitality, as well as those of ordinary citizens who live, work, and play in Port Richmond, define the civic life of the community.

31

The consolidation of the five boroughs into New York City brought an end to over three decades of self-government in Port Richmond. The farewell dinner was held at the Masonic lodge, one of the favorite meeting places of politicians for social and political gatherings. (Staten Island Historical Society.)

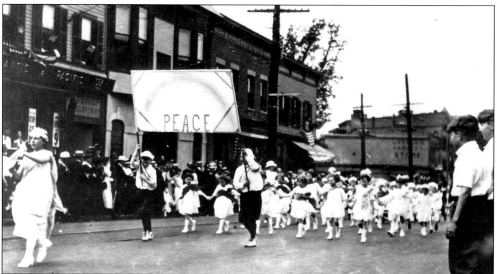

In this 1921 photograph, students from Public School 20 march in a Port Richmond Flag Day parade carrying a Peace banner decorated with a rainbow, the international symbol of peace and hope. Although World War I stimulated patriotism, the destruction that it caused spurred the peace movement in America and calls for disarmament, the outlawing of war, and international organization during the 1920s. (Staten Island Historical Society.)

Democrat Anning S. Prall was elected to Congress six times between 1923 and 1935 then served as the second chairman of the Federal Communications Commission. He was noted for his First Amendment advocacy. Born in Port Richmond, he began his career in local politics while working as a banker in 1908 and then served as president of the New York City Board of Education. He is buried in Moravian Cemetery in New Dorp. (Staten Island Historical Society.)

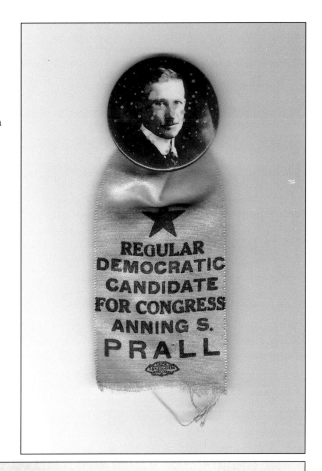

RALLY FOR GOD AND COUNTRY

A Special Patriotic Service to Celebrate the Adoption of the Eighteenth Amendment

Sunday, January 15, 1928, 7:45 P. M.

DUTCH REFORMED CHURCH

Richmond Ave., Port Richmond, Staten Island, N. Y.

HON. CLINTON N. HOWARD

"The Little Giant" of the American Platform

Chairman of the National United Committee for Law Enforcement will deliver a challenging address

"I have never heard his equal." "I hope the world can hear this modern apostle "—*Bryan.*

"The Twin Rocks of Church and State"

FOR ALL STATEN ISLAND!

Under the Auspices of the Woman's Christian Temperance Union

COME AND BRING YOUR PATRIOTIC FRIENDS

In 1928, the Dutch Reformed Church retained a political role. During the years of Prohibition from 1920 to 1933, as it was increasingly called into question, the congregation organized meetings to rally support for maintaining the 18th Amendment. (Staten Island Historical Society.)

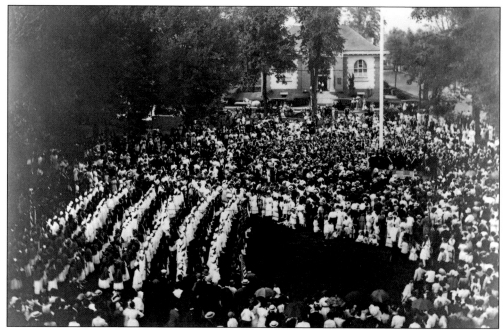

The annual Flag Day parade down Richmond Avenue was a highly anticipated event since 1911. In this 1914 image, local schoolchildren and residents created a "living flag" in Veterans Park. In 1943, the 60-foot flagpole was dedicated by Mary Kitchner, a Gold Star Mother, before 3,500 spectators. (Staten Island Historical Society.)

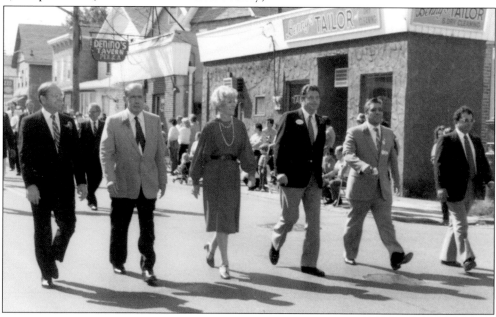

Northfield Community LDC hosted Columbus Day parades from 1979 to 1994. Here in 1979 are, from left to right, Borough Pres. Ralph Lamberti, state senator John J. Marchi, assemblywoman Elizabeth A. Connelly, and others. In 1973, Connelly became the first woman from Staten Island elected to office. The Elizabeth A. Connelly Pavilion was dedicated at the Meals on Wheels headquarters in Port Richmond. (Northfield Community LDC.)

Judge John M. Braisted established a law office on Richmond Avenue and Post Avenue in the former Griffith residence in 1905. The office remained there almost a century until 2004. According to the *New York Times*, the Braisteds descended from the original Dutch settlers of Staten Island, the Van Breestede family, who arrived in 1625. (David W. Braisted.)

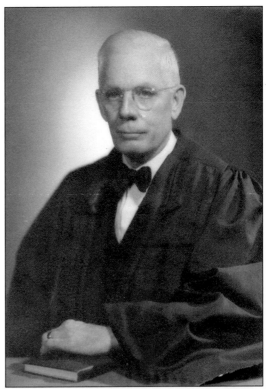

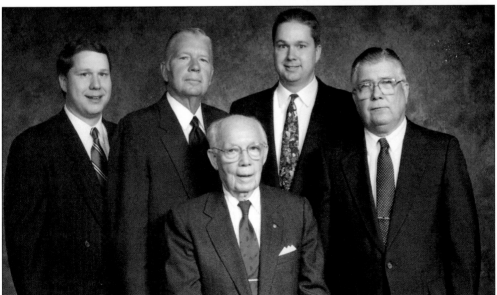

Democrat John M. Braisted Jr. (seated) served as New York State senator from 1947 to 1952, Staten Island district attorney from 1956 to 1975, and president of the Port Richmond Bar Association and of the State District Attorney Association. He was the organist at the Dutch Reformed church and a trustee of Wagner College. The family firm included, from left to right, (standing) James P. Braisted Jr., James P. Braisted, David W. Braisted, and John M. Braisted III. (David W. Braisted.)

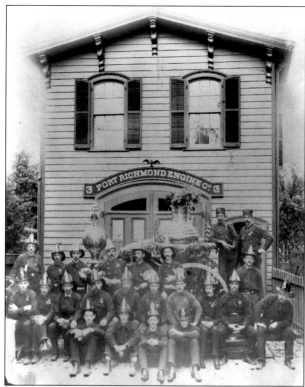

Until the 1820s, firefighting on Staten Island was confined to bucket brigades. But sometime after that date, fire companies were established. In Port Richmond, Washington Engine No. 1 (1853), Port Richmond Engine Company No. 3 (1859, pictured), Zephyr Hose No. 4 (1861), and Medora Hook, Ladder and Bucket No. 3 (1864) were formed. These companies became part of the North Shore Fire Department in the 1870s. (Staten Island Historical Society.)

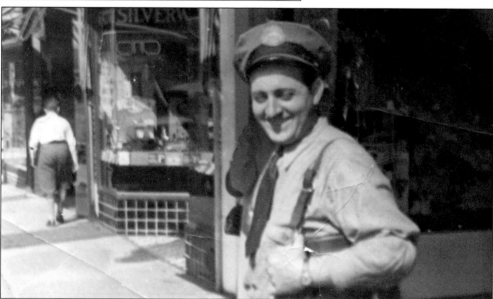

Civil servants, like mail carriers and sanitation workers, are too often overlooked when writing about a community's civic life. During World War II, Americo (Rick) Pisano, who delivered mail in Port Richmond for decades, paid special attention to overseas letters from servicemen to their families. Understanding their urgency, he rang his neighbors' doorbells after work hours to save them worrying that night. He lived on Post Avenue and later Park Avenue. (Phyllis Pisano DeMartinis.)

In 1870, the Richmond County Police Department was formed, and a substation opened where St. Philip's Baptist Church now stands. In 1888, Capt. Daniel Corsen Blake, a descendant of an early island family, was suspended for failing to enforce the county's excise law, which licensed drinking establishments. He was eventually reinstated. Blake remained captain of the county's police force until consolidation, when he became a New York Police Department captain. (Staten Island Historical Society.)

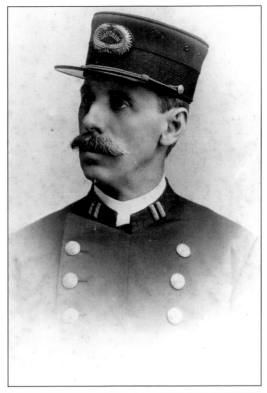

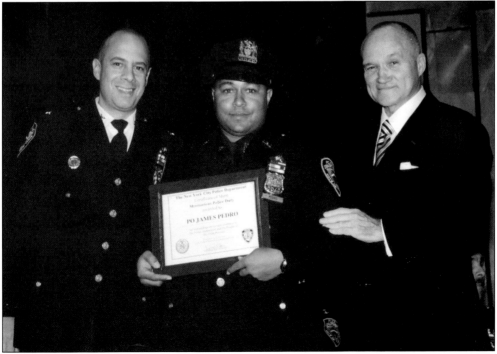

James Pedro, who grew up on Heberton Avenue, received a commendation from police commissioner Raymond Kelly. (Bertha Lee.)

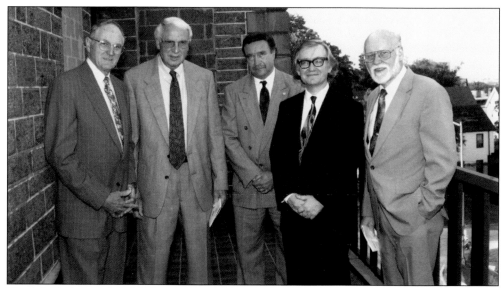

Northfield Community LDC was founded in 1978 by the residents, merchants, and property owners of Port Richmond. One of its first accomplishments was to attract major capital improvement funding to improve the streets and sidewalks and to provide matching grants for merchants and property owners to improve their stores and homes. At the 20th anniversary are, from left to right, Paul Proske (Northfield Savings Bank), Bobby Thompson, Orlando Marrazzo Jr. (chairman, Northfield Community LDC), Wally Kubec, and Lowell Johnson (pastor, Faith United Methodist Church). (Northfield Community LDC.)

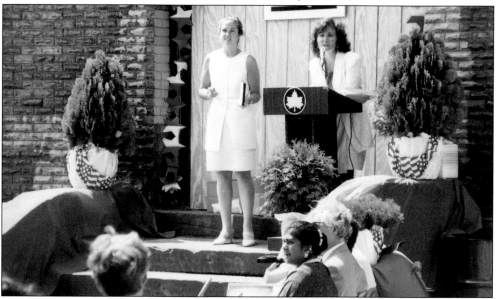

Joan Catalano (right), now executive director, Northfield Community LDC, and Kathleen Lynch-Bielsa, now deputy executive director, are seen here on the steps of Parkside Senior Housing, an ambitious $4.8 million project, in 1993. Northfield Community LDC saved the 1891 school from demolition by converting the abandoned building into apartments using city, state, and federal funding. Architectural firm Diffendale and Kubec won an Excellence in Design Award from the New York City Art Commission. (Northfield Community LDC.)

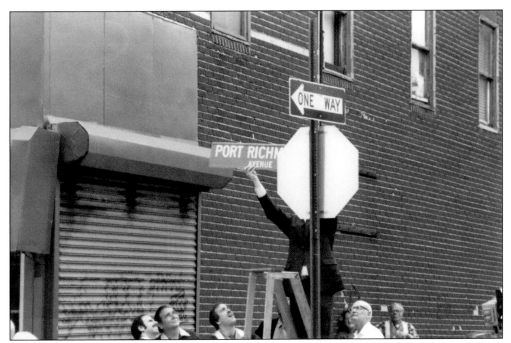

Richmond Avenue was renamed Port Richmond Avenue in 1983 as part of revitalization efforts led by Northfield Community LDC. Its first executive director was Ron Borroughs (right), owner of Everready Auto Parts. (Northfield Community LDC.)

In 1973, Camelot, a drug dependency treatment program, was created, with assistance from the North Shore Kiwanis club. Executive director Luke Nasta has served the organization for over 30 years. In the 1980s, it was involved in efforts to clean up Port Richmond. (Northfield Community LDC.)

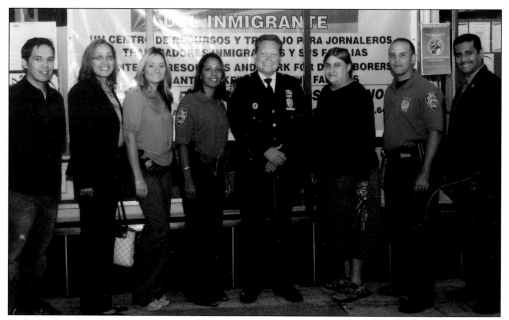

In the wake of anti-immigrant violence, Project Hospitality reached out to the police department's Hate Crimes Task Force. Project Hospitality director Rev. Terry Troia (third from right), Rev. Will Nicholls (not pictured), Gonzalo Mercado (far left), and others on staff work tirelessly to create programs to meet the needs of new immigrants in Port Richmond and to help the homeless and hungry. (Gonzalo Mercado.)

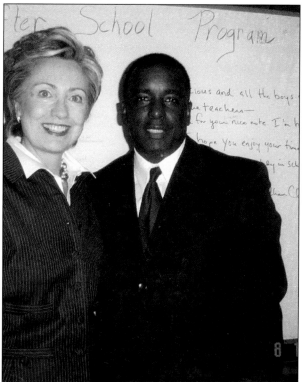

Rev. Tony Baker, pastor of St. Philip's Baptist Church since 1992, has taken an active role in community affairs. He has been a leader in the Port Richmond Anti-Violence Task Force and in efforts to bring together African American and Hispanic youth. After 9/11, he visited homeless encampments in the St. George area. He served 20 years in the U.S. Army as a sergeant first class. Hillary Clinton visited him at the church in 2008. (Bertha Lee.)

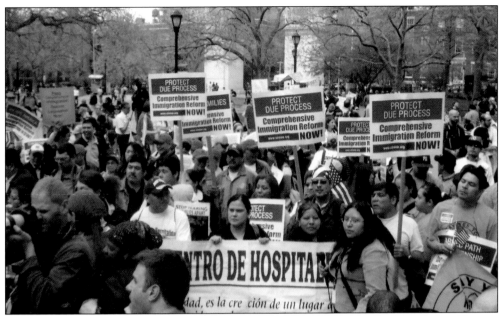

Members of El Centro de Hospitalidad (now El Centro del Immigrante), including Ramon Carreon, rally in Washington Square Park for human rights. El Centro is a collaborative effort of Project Hospitality, the Latino Civic Association, and St. Mary of the Assumption Church to serve immigrants. The center on Castleton Avenue provides workshops on immigrant rights, health education, and labor laws and operates a job center, a women's housecleaning cooperative, and a food pantry. (Gonzalo Mercado.)

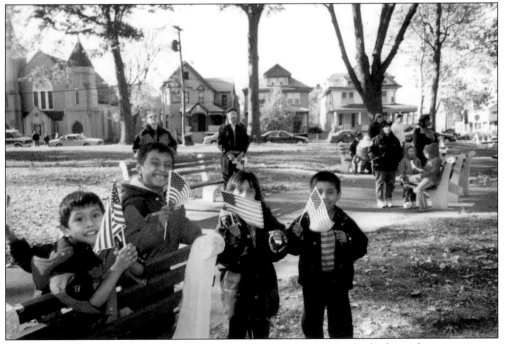

During a Veterans Day celebration, local children in Veterans Park show their patriotism. (Northfield Community LDC.)

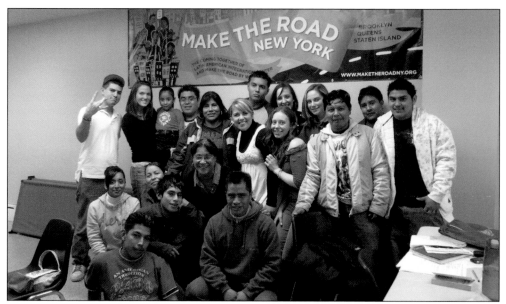

Wagner College students in Prof. Margarita Sanchez's Spanish class mentor English as a second language students at Make the Road, a partner organization of the Latin American Integration Center. Since 1997, Wagner students have undertaken civic projects within courses that connect community service to curriculum content. Other Wagner faculty have organized programs in Port Richmond, including Prof. Lori R. Weintrob in the history department and Prof. Patricia Tooker in the nursing department. (Margarita Sanchez.)

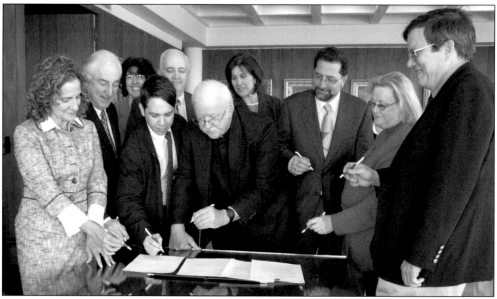

In the spring of 2009, Wagner College launched its new Port Richmond Partnership, a five-year agreement between the college and seven community partners to impact one neighborhood. Provost Devorah A. Lieberman, Pres. Richard Guarasci, and Prof. Cassia Freedland encourage student civic engagement at El Centro del Immigrante, Port Richmond High School, St. Mary of the Assumption Church, Northfield Community LDC, the CYO, and Project Hospitality. (*Staten Island Advance*, 2009. All Rights Reserved. Reprinted with Permission.)

Four

RELIGION

On August 24, 1889, the *New York Times* reported that the 224-year-old Dutch Reformed Church feted its minister, Rev. James Brownlee. Brownlee, who also served as Northfield Township schools commissioner, drew an audience from throughout New York and New Jersey, including descendants of founding members. He used the occasion to emphasize the church's contribution to the foundation of America, often overshadowed by that of the Puritans. Brownlee's 60-year tenure was noted for only one controversy: he ended segregation by race during communion services. Brownlee emphasized the dramatic changes he had seen, notably, the railroad replacing the cornfields.

Indeed, the religious life of Port Richmond had changed nearly as much as the landscape, with the arrival of German, Irish, Norwegian, Jewish, Polish, Italian, and Greek immigrants. Port Richmond's second parish, Park Baptist Church, was founded in 1841. Staten Island's first German Lutheran church, St. John's, was established in 1852. Grace Methodist Episcopal Church (today's Faith United Methodist Church) started in 1867. St. Philip's Baptist Church served local African Americans from 1876. Thereafter, immigrant groups multiplied: St. Mary of the Assumption Church (1877), the area's first Catholic church, served Irish and German quarry workers; Norwegian and Swedish shipbuilders could worship at one of four Lutheran churches that were established between 1894 and 1907; and Jewish business owners flocked to Temple Emanu-El, a Conservative synagogue (1907). The Church of St. Adalbert drew Polish newcomers, yet its pastor, who spoke Italian, aided mothers at St. Roch's Church who did not speak English. A Greek Orthodox church was proposed for Port Richmond, but a narrow vote led to its placement in Bull's Head. In 1960, Port Richmond residents were served by 10 Protestant churches, five Roman Catholic parishes, and one Jewish temple; by the 1980s, new immigrants groups, such as Filipinos, Syrians, and Mexicans, began to worship there.

Churches also served as sites for community gathering and civic activism. Pastor William A. Epps Jr. brought congregants to Selma, Alabama, during the civil rights era. Fr. Michael Flynn, Rev. Tony Baker, Rev. Terry Troia, Rabbi Gerald Sussman, and others continue this legacy of civic engagement.

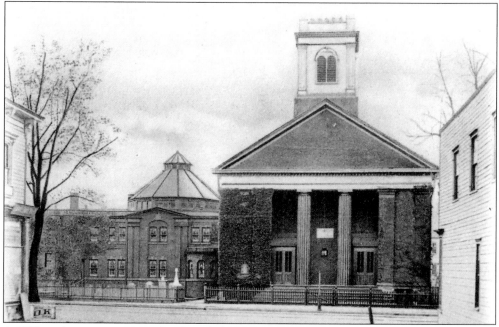

A 1705 road survey mentions the "burial place" at the Dutch Reformed church, which gave the area its first name. By 1718, Rev. Cornelius Van Santvoord was preaching in both French and Dutch to congregants of Huguenot and Dutch descent. This continued until 1742. The church was damaged during the American Revolution and rebuilt in 1786 and again in 1844. Rev. Peter Van Pelt, army chaplain in the War of 1812, was pastor from 1802 to 1835. The 1908 image above captures the prominent position of the Dutch Reformed church (renamed Staten Island Reformed Church), along with St. Andrew's Church, as two of the oldest parishes on Staten Island. The image below shows congregants marching in a parade down Richmond Avenue. (Above, Staten Island Historical Society; below, Northfield Community LDC.)

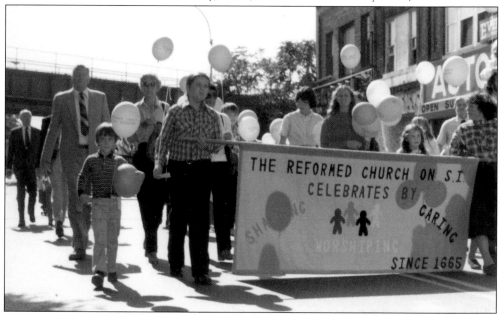

After the 33-year ministry of Van Pelt, James Brownlee began his 60-year tenure, nurturing the church's growth from 93 members in 1835 to over 400. Brownlee baptized 951 children and adults, married 656 couples, preached over 4,000 sermons, and taught Sunday school. He was brought up strictly within the Presbyterian Church of Scotland, where he was born, and spoke French, Greek, and Latin. (Staten Island Historical Society.)

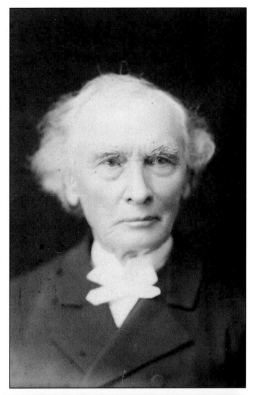

The beautiful octagonal-shaped Sunday school wing of the Dutch Reformed church was built to resemble the original 1715 Dutch church. Oscar S. Teale, who designed Harry Houdini's tomb, was the architect. Many generations of children passed through these walls. Van Pelt attempted to establish a parochial school there. (*Staten Island Advance*, 2007. All Rights Reserved. Reprinted with Permission.)

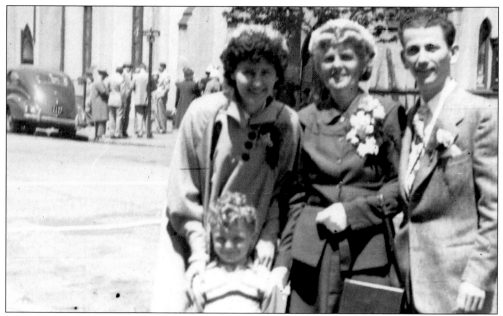

The North Baptist Church of Port Richmond, organized by members of the congregation from Fayetteville (now Graniteville), was dedicated in 1843. In 1877, the church building, remodeled in Gothic Revival style, was renamed Park Baptist Church. Rev. J. J. Muir, pastor of Park Baptist Church from 1880 to 1883, later became chaplain of the U.S. Senate. Here the Decker family poses in front of the church. (Marjorie Decker Johnson.)

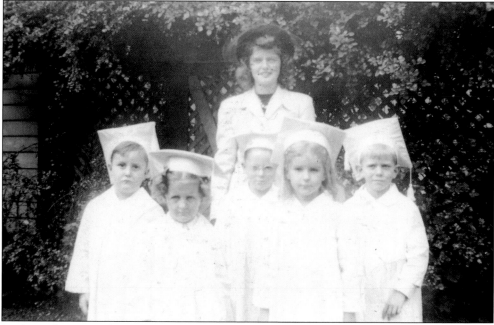

In the early 1940s, children in the Park Baptist Church Sunday school enjoy their graduation ceremony. Standing second from the right is Dorothy (Dottie) Jensen, who lived across Veterans Park from the church. George Decker is at far left. Standing behind is teacher Doris Gramlich. (Dorothy Jensen.)

The first German church on Staten Island was established on December 7, 1852, on Jewett Avenue. Four years later, the German Evangelical Lutheran Church in Stapleton (now Trinity Lutheran) was opened. Toward the end of World War I, the church was renamed St. John's Evangelical Lutheran Church. St. John's had a parochial school where lessons were initially taught in both German and English. (Staten Island Historical Society.)

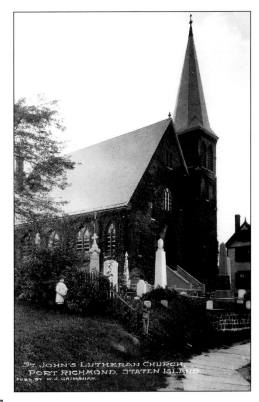

Standing on the steps of St. John's Evangelical Lutheran Church on her confirmation day is 12-year-old Alma Jean Nack. A Port Richmond native, Nack grew up on Ann Street. Her daughter Sue (Phelps) Quadrino stood on the altar of the same church at her own confirmation 22 years later. (Sue Quadrino, Lisa Gilmore, and Jean Steinhauer.)

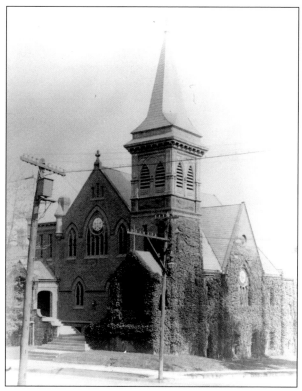

Staten Island first heard Methodist preaching in 1740. Beginning in 1771, Bishop Francis Asbury, the famous missionary, visited Staten Island 19 times. In 1867, a group from Trinity Methodist Church in West Brighton, including Read Benedict, John Q. Simonson, and John S. Sprague, formed Grace Methodist Episcopal Church at the corner of Heberton and Castleton Avenues. In 1873, the first adult Bible class was led by Sprague. In 1886, the parsonage was built. After the chapel was destroyed by fire, a new Gothic-style edifice of dark brick with terra-cotta trim was erected. Clergy from across the island attended its 1897 dedication. In 1966, Grace, Kingsley, and Trinity Churches merged to become Faith United Methodist Church. (Left, Staten Island Historical Society; below, Faith United Methodist Church.)

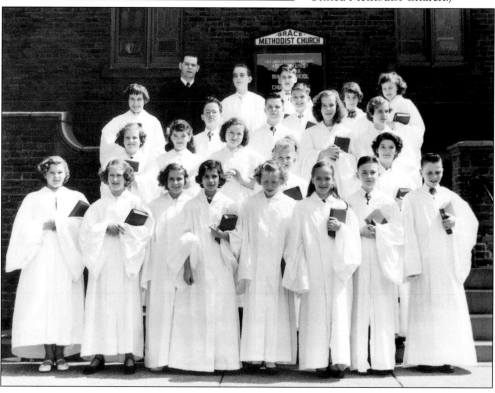

The dedication of the new Sunday school building was held on Mother's Day in 1922 during the pastorate of Rev. William J. Hampton (1918–1923). Remembering her days in a kindergarten class in that era, Lillian Olsen reminisced, "I recall wanting to go to Sunday School every Sunday wanting to go to Mrs. Charles Kinney's class, I remember her as a warm, sweet Bible teacher whose lessons were beautifully told." (Faith United Methodist Church.)

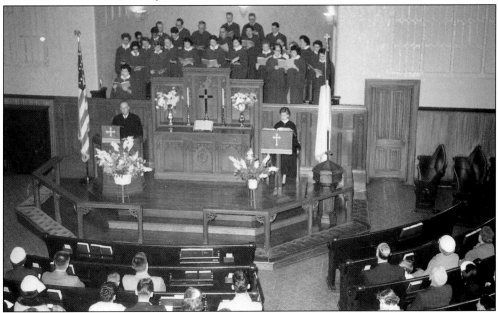

A high point for the Grace Methodist Episcopal Church choir was the arrival of Dr. Anders Emil, who organized the Staten Island Methodist Choir, which performed at the 1939–1940 New York World's Fair. Among other youth activities, the Epworth League of Grace Methodist Episcopal Church boasted 300 members in 1923 under the leadership of Vernon Hampton, the reverend's son and a prominent local historian. (Faith United Methodist Church.)

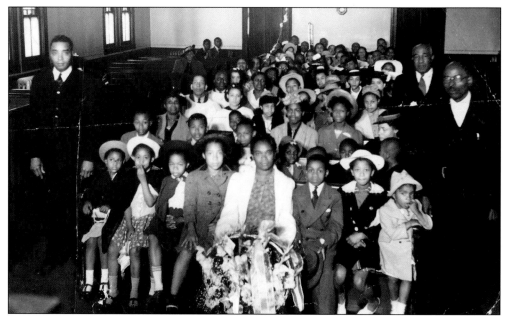

In 1877, John Taylor and Leroy Dungey of Virginia and James Pool of Staten Island organized a house of worship and then a Baptist mission, which met in Park Baptist Church. In 1881, against the protest of neighbors, lawyer Alfred DeGroot helped Thomas Dungey secure property for the church at 134 Faber Street. St. Philip's Baptist Church, formerly the North Shore Colored Baptist Mission, was dedicated on Easter in 1889 by Rev. Granville Hunt, pastor. Inside the church (above) stand Ernest Joyner and Rev. A. J. Jones (far right), assistant pastor. Ten-year-old Bertha Simons, seated in the first row, fourth from left, took two trains from Rosebank to attend. Bertha (Simons) Lee has since served as chairperson of the scholarship committee. Senior choir members seen below include organist Helen Craig (far left). The last service held at the Faber Street church occurred on February 20, 1966. (Bertha Lee.)

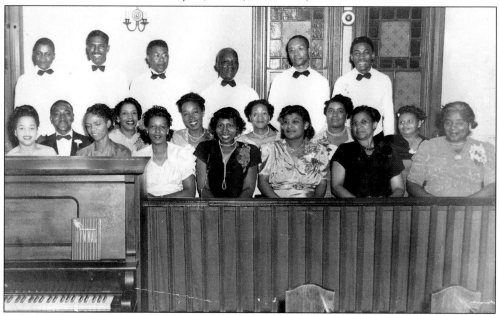

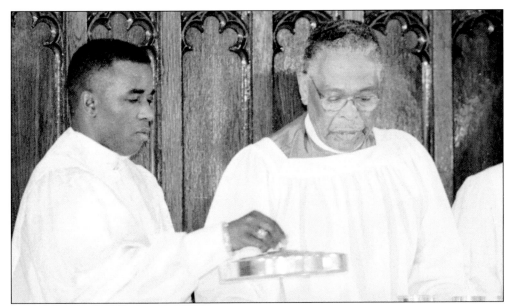

In this communion photograph, Rev. Dr. William A. Epps Jr. (right) is joined by Rev. Tony Baker. Pastor of St. Philip's Baptist Church from 1954 to 1992, Epps oversaw the growth and relocation of the church to 77 Bennett Avenue, formerly the home of Zion Lutheran Church. Born in Georgia, Epps became a civil rights activist, was jailed with Dr. Martin Luther King Jr. in Birmingham, Alabama, and served as Protestant chaplain at Arthur Kill Correctional Facility. (*Staten Island Advance*, 1996. All Rights Reserved. Reprinted with Permission.)

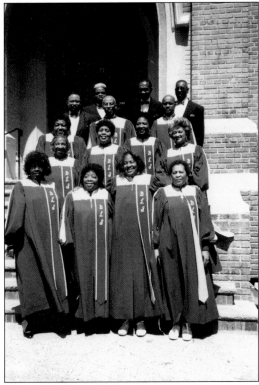

The Guiding Light Singers was founded in 1954. In the early years, they rehearsed on Van Street at Mr. Billups's funeral home. Yvonne Burkhalter, director of the choir in 1991, joined her sister, a nurse, in Staten Island in 1951. Pictured are, from left to right, (first row) Mary Early, Mabel Roberts, Patricia Young, and Bessie O'Bryant; (second row) Martha Providence, Yvonne Burkhalter, unidentified, and Sheila Etheridge; (third row) Verdell Bass, Ulysses Providence, and unidentified; (fourth row) Harold Gay, Thomas Byrd, Samual O'Bryant, and Silvester C. Engram. (Bertha Lee.)

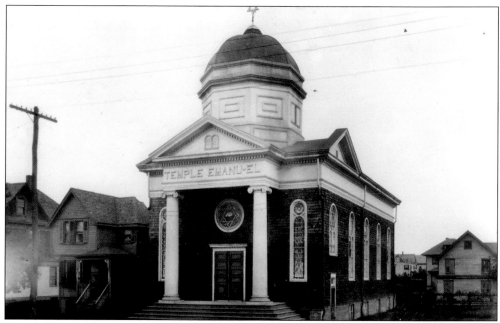

Temple Emanu-El at 984 Post Avenue was the third synagogue to open on Staten Island, following B'nai Jeshurun (1888) and Agudath Achim Anshi Hessed (1900). In 1904, businessmen Charles Safran, William Einziger, and Morris Klein laid the groundwork for a Conservative synagogue. Port Richmond architect Harry Pelcher's design resembled the synagogue in Warsaw, Poland. It was built on property once owned by Polish-born Herman Bodine. Congregant Philip Gresser, the owner of Gresser Monumental Works, purchased 1,200 burial plots from the nearby Baron Hirsch Cemetery. Temple Emanu-El held dinner dances at the German club rooms in Stapleton to raise funds for the mortgage. The first president was Austrian-born Dr. George Mord, and Albert Goldfarb became cantor. For many years, an electric Jewish star glowed from the top of the cupola to mark the Sabbath and holidays. The education building was added in 1927. The dedication ceremony is pictured below, with Bella Einziger (the wife of William Einziger), sisterhood president (center). (Above, Staten Island Historical Society; below, Temple Emanu-El.)

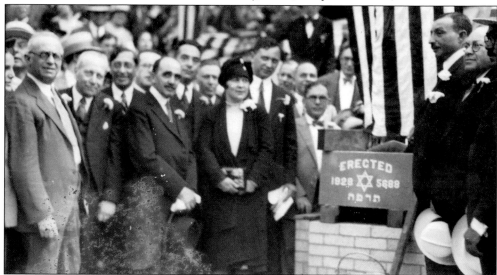

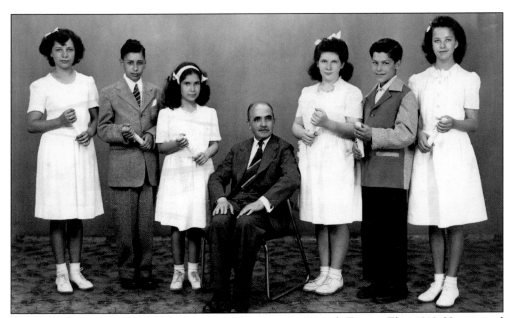

Born in Lithuania in 1875, Rabbi Issac A. Milner came to Temple Emanu-El in 1912. He received degrees in Germany and at the Jewish Theological Seminary in New York. With president Charles Safran and chairman Dr. George Mord, he oversaw the opening of the education building. In the confirmation class of 1945–1946 stand, from left to right, Roz Warnstein, Edwin Geller, Gloria Garber, Lorayne Gootenberg, Martin Greenberger (whose parents owned the Mayflower shop on Richmond Avenue), and Etta (Schapiro) Garber. (Harold and Etta Garber.)

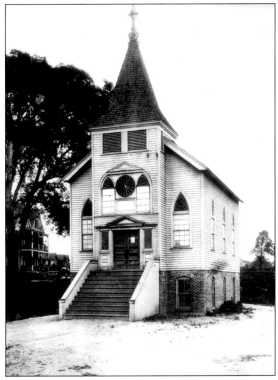

Four Scandinavian churches in Port Richmond were established in the late 19th century. The Lutheran Church of Our Savior on Nicholas Avenue (1893–1929), pictured here, was referred to as the Norwegian church. Zion Lutheran Church opened on Christmas Day in 1900 at Avenue B, then moved to 77 Bennett Avenue in 1926, and later relocated to Willowbrook Road in 1966. The Swedish Evangelical Church (1897) and the Wassa Swedish Lutheran Church (1910) also were founded. (Staten Island Historical Society.)

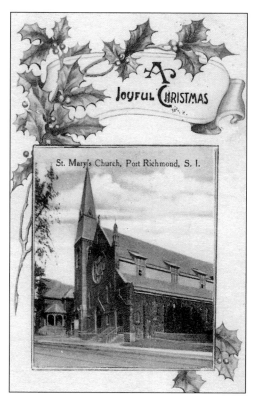

The first Catholic church on Staten Island was St. Peter's in New Brighton in 1839. St. Mary of the Assumption was founded in Port Richmond as a mission church of St. Peter's for German and Irish quarry workers in 1855. It established a Sunday school in 1873, became a parish in 1877, and in 1884, the cornerstone was laid by Archbishop Corrigan. Rev. J. C. Campbell served the congregation from 1878 to 1928. (Staten Island Historical Society.)

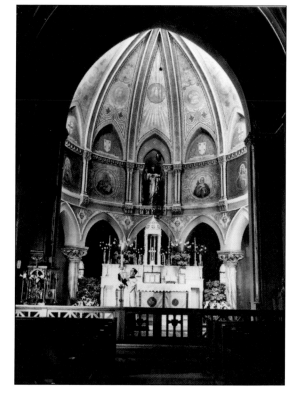

Fr. Theodore Hesburgh Sr., who later became president of Notre Dame University, served as an altar boy at St. Mary of the Assumption Church alongside Lawrence Brown in the early 1900s. Hesburgh later moved to Syracuse but spent his summers on Anderson Avenue in Port Richmond in the 1920s and 1930s. He has received 130 honorary degrees. Brown was the grandfather of Larry Ambrosino. (Staten Island Historical Society.)

Nuns of the Franciscan Order taught classes of 50 students at St. Mary of the Assumption Church. The third and fifth grades were taught by lay teachers. Students, like Linda Forte in the 1950s, attended mass every morning. (Linda Forte Verrault.)

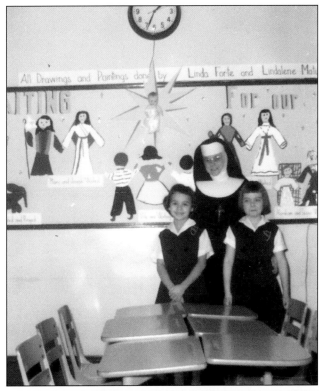

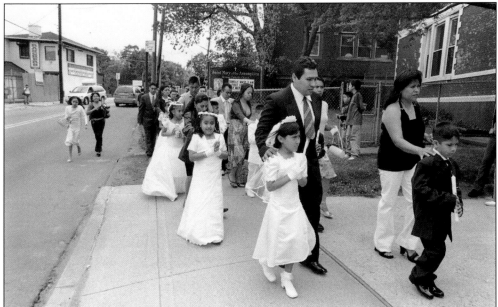

Children and their godparents proceed to St. Mary of the Assumption Church on Richmond Terrace in Port Richmond on May 20, 2006, for a mass in which dozens of children received communion. This image is part of a photo essay project on the Mexican immigrant community in New York by Irma Bohórquez-Geisler, a Staten Island photographer born in Mexico City. (Irma Bohórquez-Geisler. Photo copyright. All rights reserved. Reprinted with permission.)

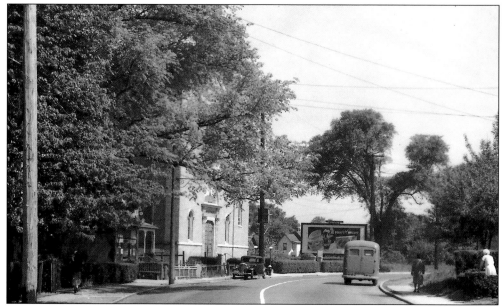

In 1922, Fr. Catello Terrone, a young Italian priest, was appointed pastor of St. Roch's Church, an Italian parish, by Patrick Cardinal Hayes, who came to dedicate the church. Originally church services were in both Italian and English. Soon Polish, Irish, Hispanic, and Norwegian members joined. In 1960, pastor Rev. Pasquale Cannizzaro of Calabria, Italy, oversaw the building of St. Roch's School and Convent, dedicated by Francis Cardinal Spellman. The men's Holy Name Society and the women's St. Ann's Guild support the school. For many years, St. Roch's bazaar was held annually on August 16, the feast day of the church's patron saint. In the 1970s, St. Roch's Church provided a youth center with basketball teams, cheerleading squads, and Boy Scout and Girl Scout troops. (Above, Staten Island Historical Society; below, Northfield Community LDC.)

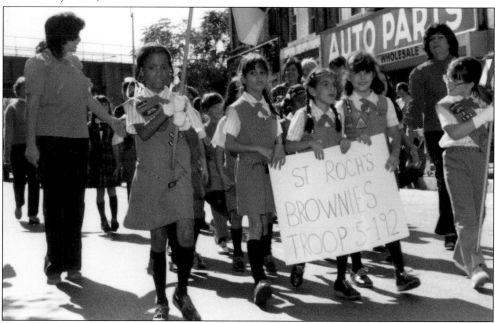

Pictured here on August 22, 1965, Rosemary Silvestro kisses her father Vincent Silvestro. Rosemary and her sister Diane sang in the St. Roch's Church choir. Vincent grew up on La Grange Place in the 1920s and lived in Port Richmond until his death. Rosemary met her husband, Louis Anarumo, at Port Richmond High School. A graduate of Public School 20, Louis became principal of Public School 53 in Bay Terrace. (Rosemary Anarumo.)

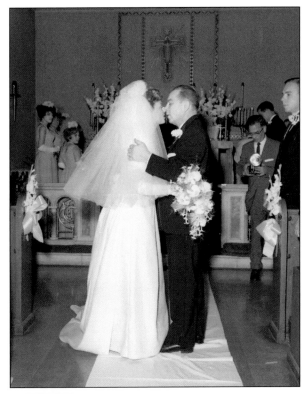

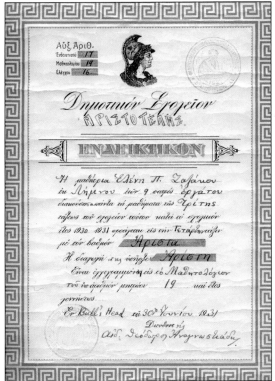

In 1927, the Aristotle Society dedicated to Greek culture and education began in Port Richmond. But in 1928, a short-lived organization rented an old Norwegian church on Nicholas Avenue for services. Eventually a permanent church called Holy Trinity-St. Nicholas Greek Orthodox Church was built in Bull's Head. (Cheryl Criaris Bontales.)

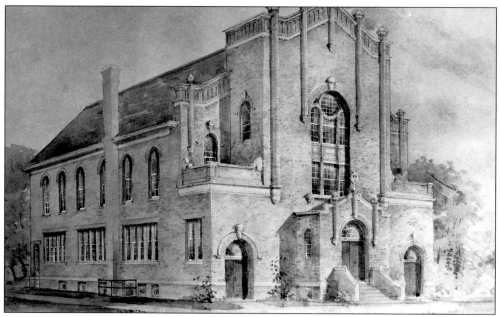

Until 1901, Polish residents of Staten Island commuted to worship on the Lower East Side. At a meeting in Elm Park that year, John Mojecki donated property on John Street in Port Richmond. The Church of St. Adalbert was dedicated as a national Polish parish. In 1921, a new church/school, pictured above, was constructed on Morningstar Road in Elm Park. A third, pyramid-shaped church was built in 1968. Polish mass was recited until 2001. (Church of St. Adalbert.)

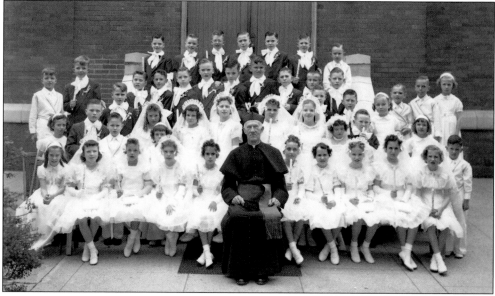

Msgr. Joseph Brzoziewski, known as "Father Joe" for 62 years, poses with the first communion children in front of the old church in May 1952. Brzoziewski studied in Rome and was fluent in Polish, Italian, and Latin. Although the church today still preserves Polish traditions, congregants are drawn from diverse ethnicities, including Filipino and Hispanic. Since 1998, Rev. Eugene Carrella, an Italian American, has served. (Church of St. Adalbert.)

Five

ETHNICITY AND
IMMIGRATION

The first settlers of Port Richmond were a mix of Dutch, French, Belgian, and African ethnicities. Historian John J. Clute speculates, "There was probably not a single inhabitant who could speak English intelligibly, if at all." During the 1700s, English settlers arrived and intermarried. Each family owned one or two enslaved persons on average, who shared the labor on farms and contributed to local prosperity. In 1825, emancipation became law in New York State and Northfield's 182 slaves (in a township of 378 families) were freed.

In the 1830s on the eve of the Irish potato famine, whether as indentured servants or in search of factory work, Irish immigrants flocked to American shores. In fact, the largest percentage population increase in Staten Island's history at any time came in that decade. St. Mary of the Assumption Church initially developed to minister to unskilled Irish and German quarry workers.

The development of the shipyards, and perhaps the 1893 European economic crisis, drew laborers from Scandinavia. Eastern European peddlers, attracted to Staten Island's factory towns but preferring the north shore location near the ferry, also settled here. Soon they were able to open stores that transformed the quiet village into a shopping mecca, at least along "the Avenue." By the 1920s, Greek schoolchildren from town or nearby farms joined the mix.

In the 1960s, Cubans arrived after the missile crisis. By the 1990s, many Filipino, Mexican, and Syrian families sought economic opportunities here.

Each wave of immigrants brought new foods, music, traditions, and culture. Over time, schools, shops, parks, churches, and politics created opportunities for multiethnic community interaction.

This late-19th-century high chair was used by Jane Du Puy, a descendant of an early Huguenot family. Huguenots were French Protestant refugees who came to Staten Island to escape persecution in Catholic France. Du Puy was the daughter of Charlotte Hatfield and William Henry Du Puy and grew up on Anderson Avenue. (Staten Island Historical Society.)

In 1884, David Martineau of Graniteville and Maude Daniell of Greenwich Village married and moved to Port Richmond. He was captain of an oyster sloop owned by his brother Abraham and was baptized in the Kill Van Kull. Their home had gas lanterns as late as the 1930s. (Marjorie Decker Johnson.)

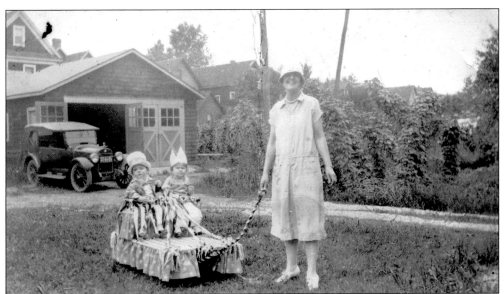

Ruth Martineau, daughter of David and Maude Martineau, entered her twins Marjorie and David Decker in the Better Baby competition of the Staten Island sesquicentennial parade in 1926 on Richmond Avenue. The image at right shows the jacket David wore when they won third place. All three sets of twins that won were born in Port Richmond. Marjorie and David were born at home on Decker Avenue in 1925. Ruth was born in 1899, attended Public School 20, and became a Sunday school teacher at Park Baptist Church. While Ruth was of both French and English descent, her husband, David Decker, a local banker, was of Dutch and English descent. Both the Martineaus and Deckers were among the earliest European settlers on the island. (Marjorie Decker Johnson.)

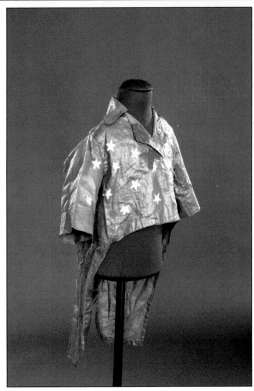

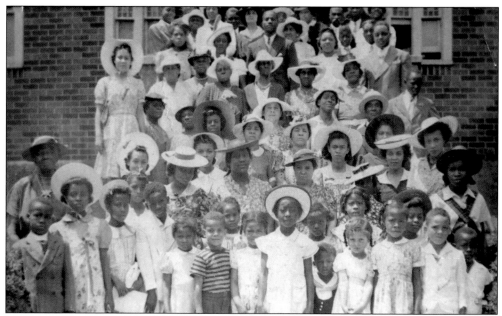

Members of St. Philip's Baptist Church pose at the Faber Street location in the early 1940s. The African American community has been present in Port Richmond for over 300 years. Over 20 percent of Staten Island's population was African American at the time of the American Revolution. The 1825 emancipation of slaves in New York State and the 1876 founding of the church are turning points in Staten Island's African American history. (Bertha Lee.)

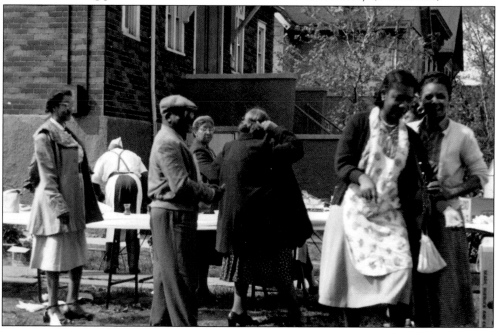

Churches, important institutions in all communities, are often at the heart of African American cultural and social life. Here congregants enjoy a picnic in front of St. Philip's Baptist Church on Faber Street. The basement was used for celebratory dinners and as a meeting place for youth groups, such as the Girl Scouts. (Bertha Lee.)

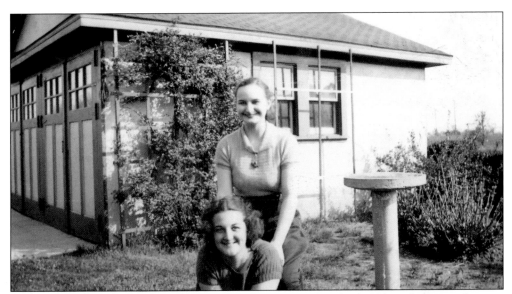

Alice Brown leans over her sister Marie, born in 1921, in their backyard on Anderson Avenue. Their father, Larry, emigrated from Luxembourg in 1896. Marie, who lost her mother at age 10, attended Notre Dame Academy. A hardworking single mother of two sons, Larry and Vincent Ambrosino, Marie was ready to help anyone regardless of race. She was employed at the Ritz Theater, Staten Island Plate Glass Company, and Western Electric. (Larry Ambrosino.)

Vincenza "Vee" Pisano worked as a seamstress at Roebell's Dress Shop from the 1950s to the 1970s. Her father came to America in 1887 from Calabria, Italy. Born in 1909, Pisano grew up on Hooker Place and attended Public School 21. She sewed dresses for her daughter Phyllis, including a mint green engagement dress, and for others in the neighborhood. (Phyllis Pisano DeMartinis.)

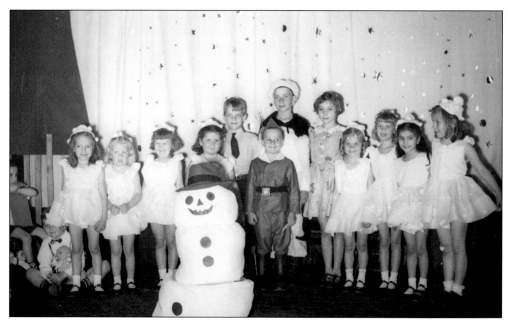

Barbara McKee, fourth from the left, performs in the Christmas pageant at Grace Methodist Episcopal Church on May 13, 1947. Her paternal grandfather, James Gibson McKee, came from Scotland, and her maternal grandmother, Emma Ludwig Scholl, was of German descent. Other children in the play were from the Braisted, DeGroot, and Housman families. (Barbara McKee Niler.)

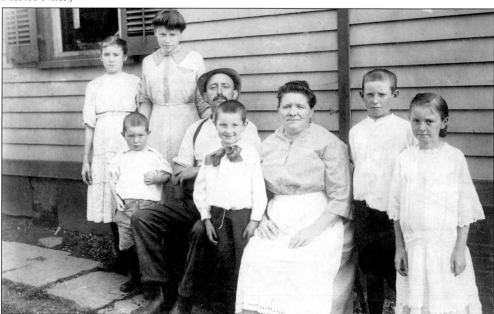

In 1896, Berhardt Krebs, a butcher from Schafenberg in southern Germany, arrived on Staten Island. He and his wife, Mary, were Catholics and ran a butcher shop on Morningstar Road. Upon their deaths, 17-year-old daughter Carrie helped provide for her siblings Josephine, Bernie, William, Theodore, and Mary by working at the Unexcelled Fireworks Company in Graniteville near the Baron Hirsch Cemetery. (Edward Pedersen.)

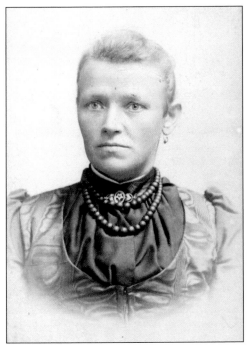

Grandparents Louise and Gregers Jensen of Risør, Norway, came to Port Richmond in the 1880s. Gregers, a saw master, worked in the shipyards along Richmond Terrace, as did five of his sons. They hosted seamen at their home and sold passage on ships. Louise had been an ardent member of the Women's Christian Temperance Union (WCTU), a group based in Prohibition Park. (Dorothy Jensen.)

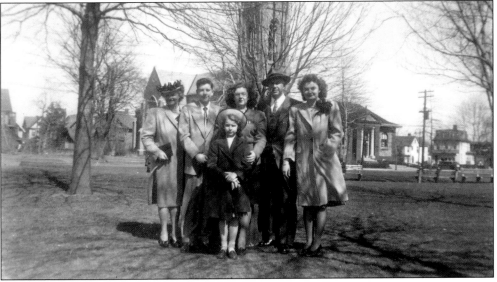

Alice Callahan (standing on the far left), of Irish descent, and her children Robert, Peggy, Mary Jane, and Dorothy greet her husband Dr. Leif Jensen on his discharge from the navy. Alice was state president of the Women's Auxiliary of the Medical Society of New York and president of the Public School 20 Parent-Teacher Association. Leif served in the navy, was chief of surgery at Staten Island Hospital, and was a charter member of the Sons of Norway. (Dorothy Jensen.)

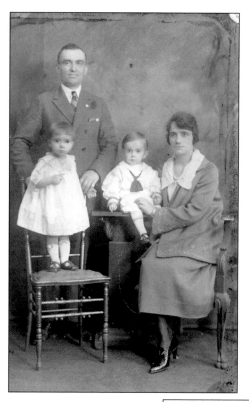

Melania, from the Ukraine, and Henry Brudienski, of Poland, had their names changed to Mildred and Henry Brusda when they came to America. They moved from the Lower East Side to Port Richmond in the 1920s. Their granddaughter Denise, whose mother was Italian, attended St. Mary of the Assumption Church. She long admired the church's painting of Titian's *Assumption of the Virgin* and finally saw it in Venice. (Denise Brusda Caruselle.)

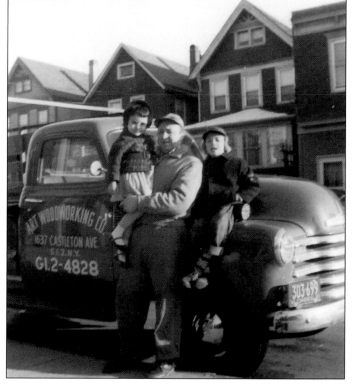

Pat Forte began the Art Woodworking Company in 1952 at 462 Richmond Avenue. He relocated to 1637 Castleton Avenue so his family could live above the store. His handiwork could be seen in the St. Mary of the Assumption Church rectory and convent and in churches throughout New York City, due to Msgr. John J. Cleary's recommendation. Leaning against his company truck, Forte holds his daughter Linda, while his son Ray sits on the hood. (Linda Forte Verrault.)

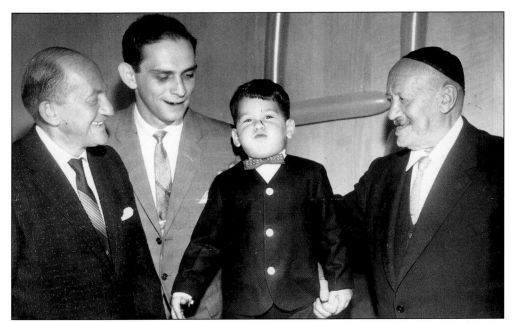

In this 1958 photograph, Louis Garber, one of the founders of Garber Brothers, celebrates the 39th anniversary of the store with his son Harold, grandson Barry, and father, Abraham. Abraham, raised in Gaberna Shtetl, Poland, was very religious throughout his life. Drafted into the Russian army, he served briefly in Siberia before fleeing due to anti-Semitism and coming to the United States in 1911. (Harold and Etta Garber.)

In 1951, Etta Schapiro, an occupational therapist at St. Vincent's Hospital, married Harold Garber after they met at a dance at the Jewish Community Center. In this image, her paternal grandfather, Abraham Schapira, poses in Poland with his three daughters. Not pictured is his son Louis, Etta's father, who came to Elm Park in 1918. Much of their family perished in the Holocaust. (Harold and Etta Garber.)

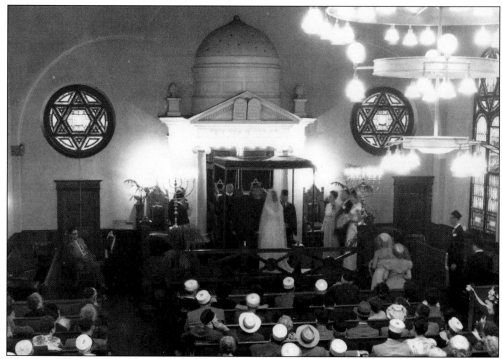

The ark of Temple Emanu-El, which echoed its exterior architecture, is visible here in the 1948 wedding of Rosalie Horn and Jacob Brayman. (Bob Brayman.)

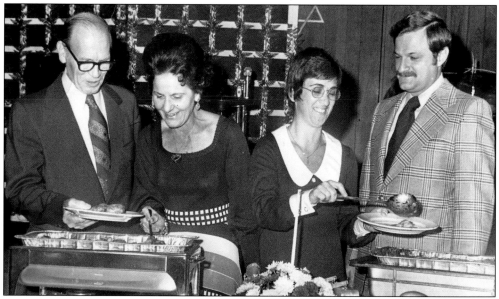

Ruth Blum (second from left) met her husband Abraham Baker at the annual Yom Kippur dance at the Jewish Community Center. She recalls that on that holiday, the Tompkins Bus Company ran a free bus from the St. George Ferry to Baron Hirsch Cemetery. Of German descent, Blum attended Public Schools 19 and 20 and Port Richmond High School. She is one of the founders of the Staten Island Jewish Historical Society. Also pictured are Marianne and Bernard Tulman. (Temple Emanu-El.)

In 1919, 17-year-old Filomena Puca married John Merlino in Naples. They journeyed to New York and raised 12 children in Port Richmond. When the film *Cheaper by the Dozen* was released in 1950, the Merlino family was given free passes to see it at St. George Theater. Among their children's achievements, in 1993, Dr. Lina Merlino, a pediatrician, was elected the first woman president of the Richmond County Medical Society. (Ann Merlino.)

In the front yard of her house on Richmond Avenue wearing traditional Greek costume is Helen Zazakos. She graduated from Port Richmond High School in 1938, two years after her husband, William Criaris. Zazakos's parents, Peter and Kerasto Zazakos, immigrated to New York from Limnos, Greece, around 1912. William's family owned a farm in Bull's Head on which the famous African American poet Langston Hughes worked. (Cheryl Criaris Bontales.)

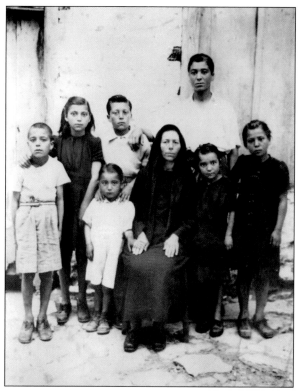

This photograph, taken in Anavriti, near Sparta, Greece, shows Martha Panagakos (center) with her children, from left to right, (first row) Peter, Elisabeth, and Helen; (second row) Gus, Julia, John, and Nick. They suffered greatly during World War II and the Greek Civil War (1946–1949). Panagakos's husband, Peter, was killed in 1943 during the Nazi occupation of Greece. The family immigrated to America in the 1950s, living briefly in the Port Richmond home of James and Georgia Katsoris. (Nicholas and Elisabeth Papas.)

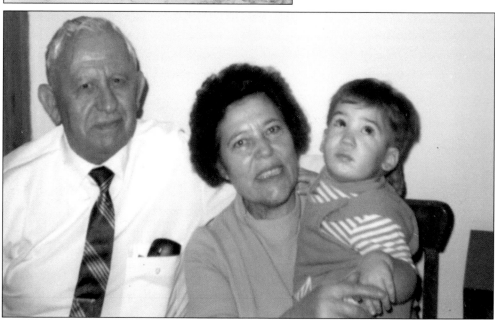

James and Georgia Katsoris, seen here with their godson Phillip, brought Georgia's widowed sister-in-law Martha and her family to America. James, who was born in Malaos, Greece, worked at his cousin Emmanuel Katsoris's ice-cream parlor on Richmond Terrace. He eventually opened Kayes Luncheonette on Richmond Avenue. The luncheonette became known as Perry's when James sold it to Perry and Helen Thanasoulis in the 1950s. (Nicholas and Elisabeth Papas.)

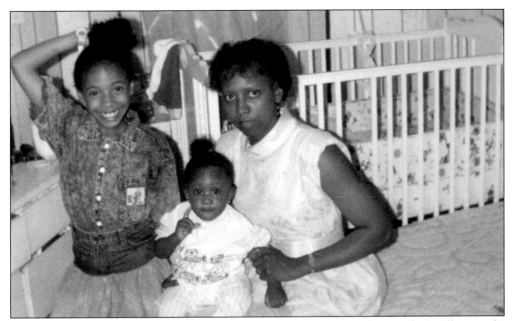

Like the earliest settlers, Elva Arrindell Randle, born in Aruba in the Dutch Antilles, speaks Dutch fluently. Elva also speaks Papiamento. At age 15, she moved to the Netherlands before settling in Staten Island, where she works with disabled children. In 1984, she joined St. Philip's Baptist Church and currently heads their youth ministry. Daughters Antia, age eight, and Leticia, two, pose in this 1989 photograph. (Elva Randle.)

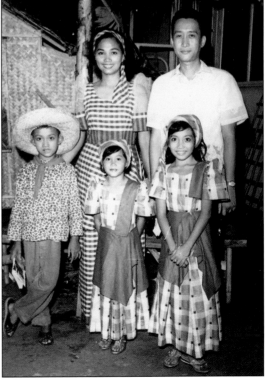

Annie M. (Maddela) Mercado, a teacher, and her husband Jose S., administrator at an oil refinery, pose with their three children, Joey, Marie Louise, and Joanne, at a traditional fiesta in Batangas City, Philippines. Now retired, they live in Parkside Senior Housing (former Public School 20). Jose and Annie came to Staten Island in 1997 when their son Joey became pastor of the Jesus the Messiah Church on Jewett Avenue. (Annie and Jose Mercado.)

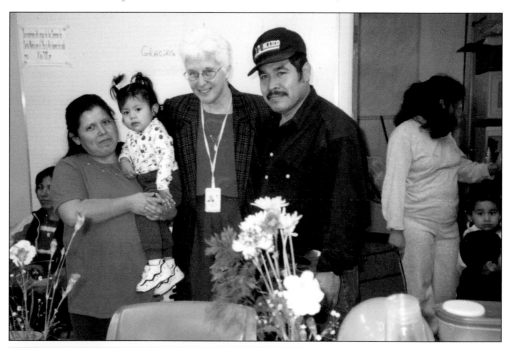

Named a Staten Island Woman of Achievement in 2004, Emma Vidals has played a vital role in the success of El Centro de Hospitalidad and the integration of Hispanic families in Port Richmond. She works the food pantry, joins rallies for immigrant rights and workshops for women's empowerment, and cooks picadillo and other foods for local day laborers. She moved here in 1997, six years after she left Mexico, to join her husband, who runs a gardening business. Her brother Adrien, who arrived in Port Richmond in 1982, was hired and mentored by an Italian American landscaper. In the image above, she is shown with her daughter Patricia and Sr. Kathy Byrnes of St. Vincent's Hospital. The image at left shows two of her seven sons in their hometown of Puebla, near Mexico City. (Emma Vidals.)

Six

ENTERTAINMENT, SPORTS, AND RECREATION

As late as the 1920s, many children from the Port Richmond area enjoyed swimming in the Kill Van Kull. Some, like Reif Nolan, the uncle of Bob Farrell, even swam across to Bayonne, New Jersey. But swimming in the waterway ended as the water quality declined and container ship traffic increased. The opening of Faber Pool in 1932, one of the first public pools in New York, provided children with a safer alternative. Concerts, picnics, and community events continue to be enjoyed at both Faber and Veterans Parks, the latter the first public park on Staten Island.

By 1924, Port Richmond had three theaters—the Empire, Palace, and Ritz—earning it the nickname "Times Square of Staten Island." Audiences flocked to these theaters to watch vaudeville shows, cartoons, newsreels, and double features. By the late 1960s, the Ritz hosted roller-skating and rock concerts. Young people enjoyed Dew Dale's record shop, owned by Axel Stordahl, who arranged songs for Frank Sinatra. At the CYO in the Masonic hall, Staten Islanders danced to tunes sung by local crooners and participated in sports such as basketball, volleyball, and boxing.

From ringside seats at the Coliseum on Richmond Terrace, in the stands at Sisco Park (later Weissglass Stadium), and from the bleachers of Port Richmond High School, crowds cheered their favorite athletes and drivers in stock car races. Talented musicians, such as David Johansen; writers, including Paul Zindel; and photographers, like John Gossage, got their start here. Now an acclaimed international photographer, Gossage did his first assignments for the *Staten Island Advance* and for a photo exposé of Port Richmond High School in *Esquire* magazine in 1965. Author and filmmaker Buddy Giovinazzo, now living in Berlin, is another talent from Port Richmond. Also noteworthy in music from an earlier era, Dolly James, who first sang in the St. Mary of the Assumption Church choir, became a prima donna at the Metropolitan Opera House in 1900.

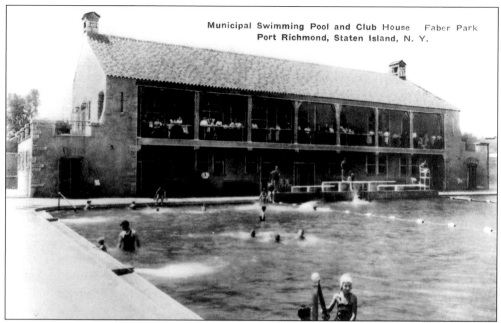

The waterfront estate of the Faber family was transformed into Faber Park and Pool in 1932 to discourage children from swimming in the polluted waters of the Kill Van Kull. The California-style design of architect Frederich H. Zurmuhlen Jr., built of stone with 18 different natural hues, was highly praised. For decades, the pool drew youngsters for swimming lessons and recreation, notably in the morning. A 10¢ fee applied in the afternoon. (Staten Island Historical Society.)

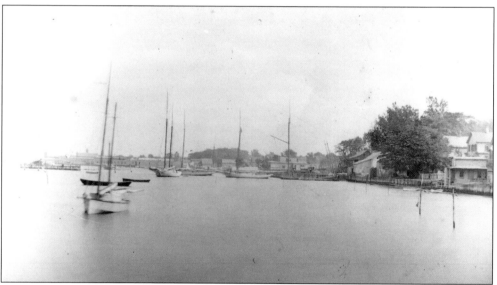

In the 1890s, yachting was a popular recreation enjoyed by those like J. Eberhard and Lothar W. Faber, descendants of Casper Faber, who established a lead pencil company in Germany in 1761. A century later, J. Eberhard built the firm's lead pencil factory in Brooklyn. In 1906, that land was purchased from Jenny Faber by the city and turned over to the parks department in 1928. (Staten Island Historical Society.)

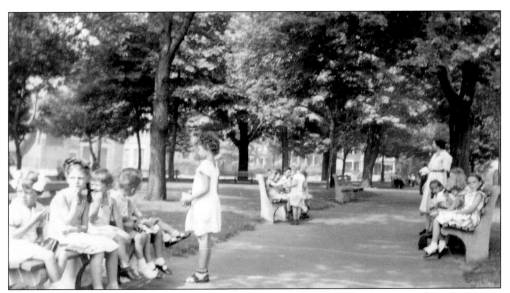

Staten Island's oldest park was laid out in 1836 as a village green or commons when the streets of Port Richmond were mapped. The Haughwout family donated the land. It was renamed Port Richmond Park in 1898. In 1949, as a tribute to American veterans, it was renamed Veterans Park. A large, decorative water fountain memorializes Eugene G. Putnam, principal of Public School 20 for 17 years. (Faith United Methodist Church.)

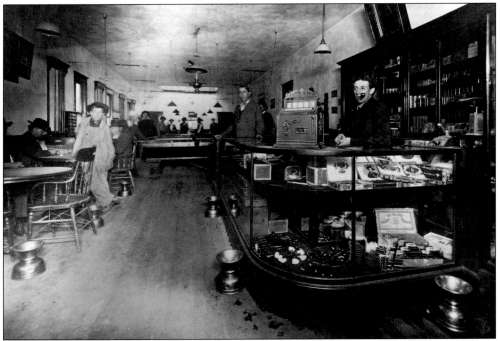

In the 19th century, pool halls were popular gathering places for Staten Island workers of all ages. Alcoholic beverages, chewing tobacco, cigars, and smoking pipes were sold by a well-dressed proprietor. This pool hall was located on the second floor of the Griffith building at Port Richmond Square. Note the spittoons on the floor, which social reformers frowned upon as unsanitary and the cause of hygienic problems in such establishments. (Staten Island Historical Society.)

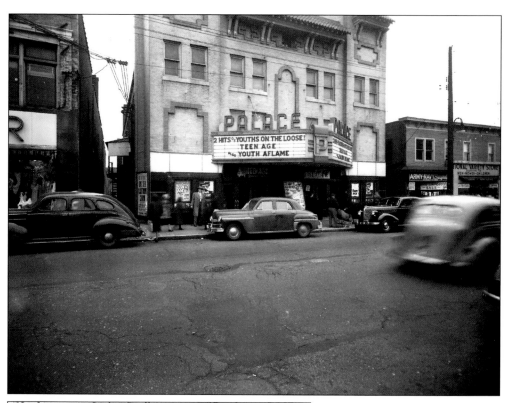

The first theater in town, built in 1915 near Port Richmond Square, was the Palace Theater. Under the management of the Moses brothers, the 980-seat theater drew audiences with photoplays and traveling troupes. It was torn down in 1951. As discussed at left, prejudices against movie houses and new immigrants found expression in this 1915 diary entry by Ida Dudley Dale, a participant in local civic organizations. "We were more than shocked & disgusted to read how fine girls were selected, like animals, as ushers for a new picture show in Port Richmond. . . . Just a few years ago, S.I. was as good and innocent a place as one could find in the State, but the Picture Shows & their Jew managers, came, & all the color of the place has been changed." (Staten Island Historical Society.)

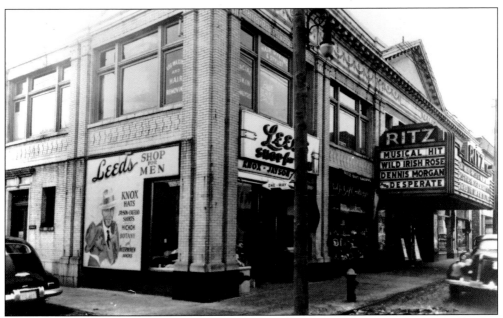

The Ritz Theater, on "the Avenue" near Anderson Avenue, was one of three theaters that earned Port Richmond the nickname "Times Square of Staten Island." Built in 1924, the town's most ornate and most expensive theater held more than 2,100 seats. Audience members could watch movies or vaudeville shows accompanied by the Ritz Orchestra. Double features cost 20¢ in 1948. (Staten Island Historical Society.)

In the 1970s, the Ritz Theater was a major venue for rock bands such as Jethro Tull, Jefferson Airplane, Black Sabbath, and the Kinks. In the 1980s, it became a roller-skating rink. In contrast, by the late 1960s, the Empire Theater on Richmond Terrace had been transformed into a venue for pornographic films. (Cheryl Criaris Bontales.)

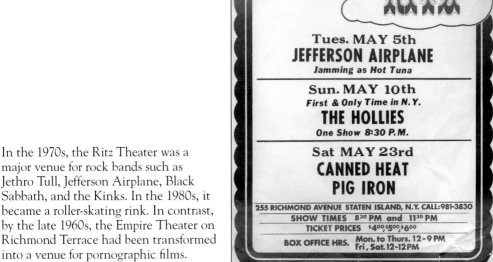

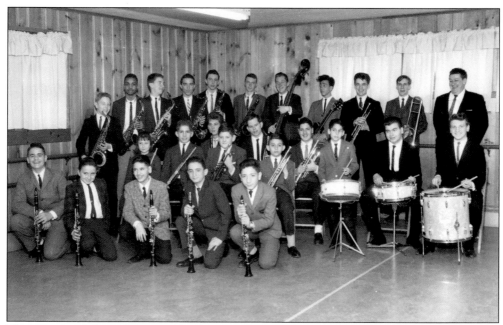

The music and dance lessons offered at Wright Music Studio were popular with young Port Richmond residents. In this photograph, young musicians pose with their instruments. Another popular music venue, Dew Dale's record shop on "the Avenue" near Stechmann's, was owned by Axel Stordahl, who became the first arranger for Frank Sinatra. (Cheryl Criaris Bontales.)

Dances at the CYO, located in the former Masonic hall on Anderson Avenue, attracted young Staten Islanders. The CYO of the Archdiocese of New York was created to help "America's youth, including the underprivileged, through activities focused on body, mind and soul." Local talent performed on its stage, and weddings were held in the gymnasium. (Catholic Youth Organization.)

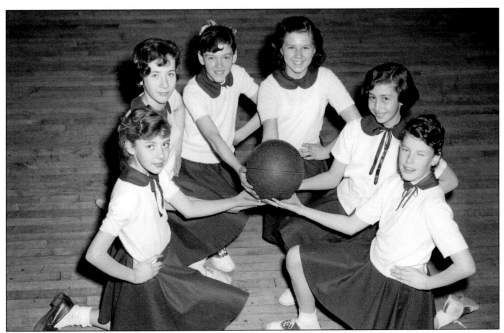

Over 60,000 youth in New York State enjoyed track, bowling, boxing, softball, and hockey at CYO facilities. In 1955, the New York CYO operated the largest basketball league in the country, with 741 parish teams involving both men and women. Directors of the CYO included Sonny Grasso, Eugene J. Obermayer, Joe Panapinto, and Judy Trancucci. (Catholic Youth Organization.)

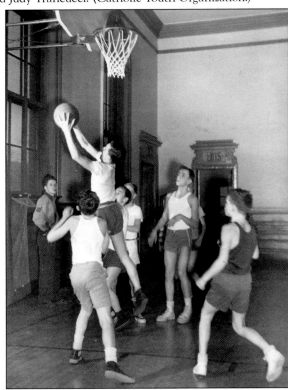

Among the athletic stars who credited the CYO for their early athletic formation was Dino Mangiero, a professional football player. The former Seattle Seahawks nose tackle and Rosebank native grew up playing basketball at the CYO in the 1970s. (Catholic Youth Organization.)

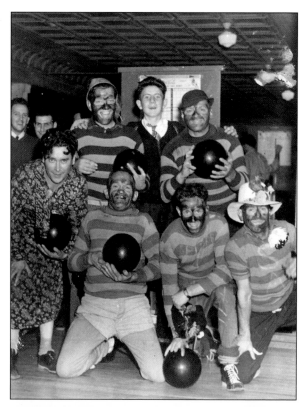

Bowling was a popular recreation in America in the 20th century. In Port Richmond, teams competed at lanes at the CYO, Temple Emanu-El, and the Coliseum Bowling Alley on Richmond Terrace. (Catholic Youth Organization.)

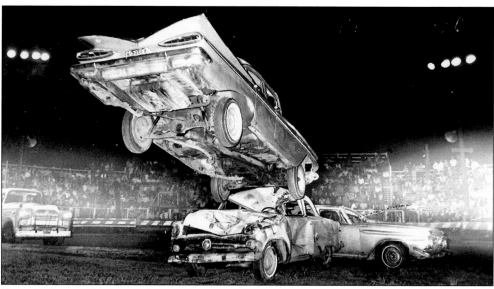

From 1953 to 1972, Weissglass Stadium hosted stock car and motorcycle races, demolition derbies, high school and exhibition baseball and football games, the circus, and a farmer's market. After 1956, promoter Gabe Rispoli offered spectators a "thrill a minute" on Thursday and Saturday nights. Cars negotiated the high-speed turns of this one-fifth-mile oval asphalt track. Collisions were many and rivalries were intense. (*Staten Island Advance*, 2004. All Rights Reserved. Reprinted with Permission.)

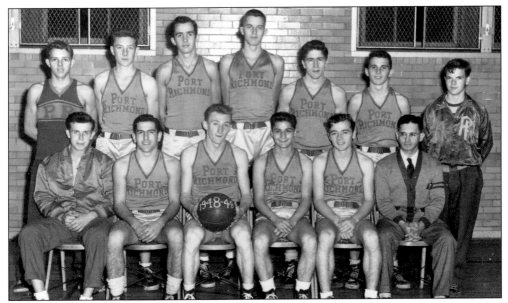

In 1948, the Port Richmond High School Minstrels, with Larry Lovington as their center, won the island title and played Madison Square Garden, nearly becoming city basketball champions. Once called the Red Raiders, their name changed after a 13-game winning streak in 1933. Lovington's brother Ted was known for a six-foot high jump two years earlier. Other famous athletes from the school include Walter Fenley (Boston Celtics), William Shakespeare (Notre Dame), Cliff Brantley (Philadelphia Phillies), and Shannon Payne (softball). (Ted Lovington.)

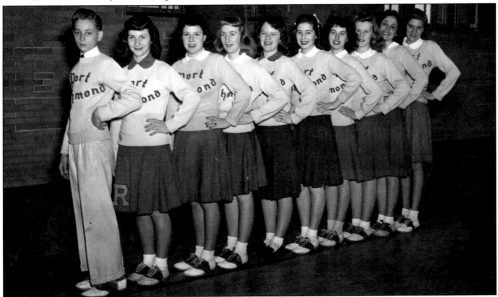

At baseball and basketball games, cheerleaders inspired fans to give hearty cheers to rally their teams to victory. "We weren't just performers, we were really 'cheer' leaders," explained Evelyn Otten, president of the 1946 Cheerleaders Club. Otten's father migrated in 1888 from Germany. Pictured are, from left to right, Buddy Keithline, Otten, Jean Puccarelli, Mary Thompson, Jeanne Martin, Edith Polsky, Betty Lynch, Sally Thompson, Marie Sweeny, and Anna Brennan. (Evelyn Otten McDonald.)

Raised by single mother Betty Zindel, Paul Zindel became editor in chief of the Port Richmond High School newspaper, the *Crow's Nest*, in 1954. He taught science at Tottenville High School after graduating from Wagner College. His play *The Effects of Gamma Rays on Man-in-the-Moon Marigolds* earned the 1971 Pulitzer Prize for drama. *The Pigman* and his later novels captured the imagination and angst of teenage readers. (New York Public Library Archives, Astor, Lenox and Tilden Foundation.)

A graduate of Port Richmond High School, Dolores Morris returned there as a teacher. In the tradition of her aunt Evelyn Morris King, a notable African American historian, she contributed to the school's nascent black studies program. In the 1980s, she directed ABC after-school specials and currently serves as vice president of HBO Family and Documentary Programming. She has won five Emmys for shows such as *Through the Eyes of a Child: 9/11* and *Happy to Be Nappy*. (William Morris Jr.)

A 1967 graduate of Port Richmond High School, David Johansen, of Irish and Norwegian descent, became known to millions as Buster Poindexter with the song "Hot, Hot, Hot." He became lead singer for the New York Dolls, a punk rock group, performed on *Saturday Night Live*, and starred in movies such as *Scrooged* with Bill Murray. In 2007, he wrote a musical tribute to the New York Chinese Scholar's Garden in Snug Harbor. (James R. Wright.)

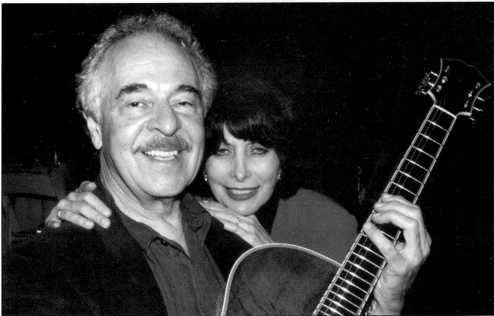

The jazz guitarist John Pisano, pictured here with wife Jeanne, a scat singer, played for local teens in the 1950s at jam sessions in the basement of 150 Park Avenue. He has accompanied in concert or recorded with some of music's biggest names, including Natalie Cole (on the album *Unforgettable*), Frank Sinatra, Burt Bacharach, Tony Bennett, Peggy Lee, and Barbra Streisand. Pisano was an original member of the Tijuana Brass. (Phyllis Pisano DeMartinis.)

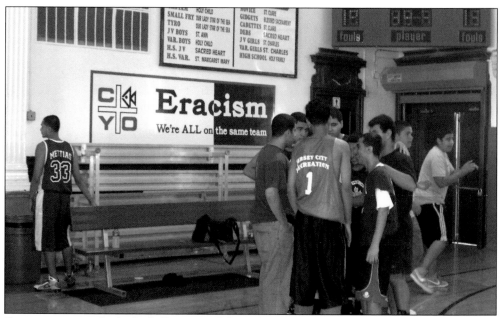

Competitions on the basketball courts of the CYO attest to its continuing impact. The logos on the walls reflect the religious and ethnic diversity of the dozens of local parochial schools that compete, including Miraj Islamic, the Jewish Community Center, Coptic Orthodox Church, and the Church of St. Adalbert. In the basement, a senior citizens program thrives. (Lori R. Weintrob.)

Mexican dancers entertain local residents in Faber Park at the 2008 Cinco de Mayo celebration. This holiday, celebrated primarily in the Mexican town of Puebla and in the United States, marks the date when Mexican troops defeated a better-equipped French army in the battle of Puebla on May 5, 1862. It is not Mexican Independence Day, which is September 16. (*Staten Island Advance*, 2009. All Rights Reserved. Reprinted with Permission.)

Seven

FOOD AND DRINK

African American poet Langston Hughes, who worked on the Criaris farm in Bull's Head in the summer of 1922, expressed his pleasure in visiting town on his Sunday afternoons off: "Sometimes some of the fellows went into Port Richmond to find girls and wine."

Hughes's comment is even more poignant as it was the era of Prohibition (1920–1933). He was not alone in enjoying his drink. Monroe Klein's uncle Charles Safron, who later founded Safron Liquor and Temple Emanu-El, worked as a bootlegger under the nose of the lighthouse service. Although only a stone's throw from Prohibition Park (now Westerleigh), one of the most important temperance communities in New York, evidence suggests that Port Richmond was not a dry town. Since the 1700s, the King's Arms Tavern, Roemer's Tavern, and later Buffalo Head Tavern advertised their spirits. By the late 1800s, Port Richmond boasted 43 saloons. As late as the 1960s when wine was easily available, many residents still preferred to make it themselves in their own backyards.

In the 1920s and 1930s, vegetable gardens were common, peach trees were ubiquitous, and rabbits could be caught in the woods around Trantor Place. The iceman and Weissglass's milk cart were pulled by horses. The meat man, by day, and Ralph's Ices, at night, came in Model T trucks. On Port Richmond Square, Katsoris's ice-cream parlor served theatergoers.

From 1936 to 1975, Stechmann's cherry Cokes were all the rage, particularly for the preppy crowd, while the greasers hung out at Perry's Luncheonette. Besides offering hangouts, food establishments, including Jewish delicatessens, Greek diners, and Italian restaurants, reflected Port Richmond's growing ethnic diversity. Two giants of this era remain: Ralph's and Denino's. Today's new restaurants offer authentic Mexican dishes that could be enjoyed by all Staten Islanders as much as the ethnic cuisine of old.

OPENING!

SALOON AND HOTEL

Will be opened the first of July on the west side of

Richmond Avenue, near Bergen Point Ferry, Port Richmond, S. I.,

and is recommend to the public for Eckstein's Lager Beer and First Class Wines, Liquors and Segars. Also Pool and Reading Room.

K. JACKSON, Proprietor.

En Saloon og Hotel, bliver aabnet den 1ste Juli, 1904. Paa vestsiden af Richmond Ave., Port Richmond, Hjörnehuset ligeved, Bergen Point Ferge. Som anbefales til Skandinavers velvillige sögning. Flere Norske og Svenske Aviser bliver udlagt til fri afbenyttelse. Billiard-værelse. Nogle Möblerte Værelser, bortleies til rimelige priser.

ERBÖDIGST K. JACKSON,

INDEHAVER.

During the American Revolution, Capt. Issac Decker, a Loyalist who served the British army during its occupation, ran King's Arms Tavern near Decker's Ferry. Customers could find not only "the best of liquors, eatables and lodgins" but also "everything that the market of New York affords." These two images, from about a century later, show how important food and drink remained to new immigrants and other residents. Eckstein's lager beer, wines, cigars, pool tables, and a reading room are advertised in the flyer at left in both English and Norwegian. In the image below, the Northfield Hotel, located at Ferry Street and Richmond Terrace, provided lodging as well as food and lager beer. Note the advertisement in German. (Staten Island Historical Society.)

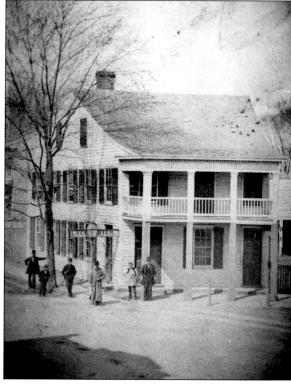

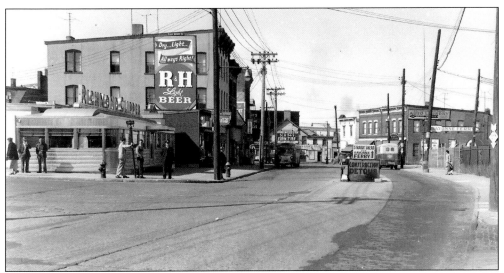

This 1951 photograph showcases the Richmond Clipper diner and advertisements for R&H light beer. Joseph Rubsam and August Horrmann were German immigrants based in Stapleton who built on the lager tradition. (Staten Island Historical Society.)

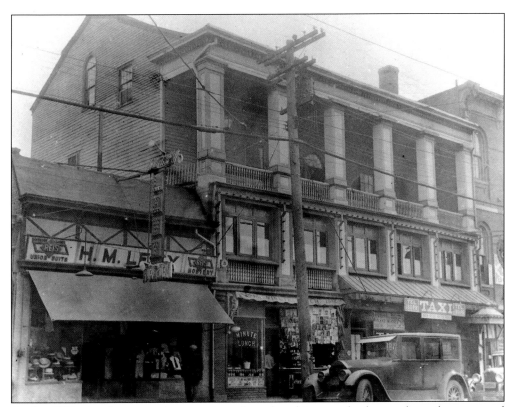

By the 1930s, luncheonettes became sites where bus drivers and other workers, shoppers, and passersby could pick up a quick bite. This was captured by the name Minute Lunch, which was located beneath the old St. James Hotel. (Staten Island Historical Society.)

Before the era of supermarkets and refrigeration, residents needed to buy fresh meat daily. William H. Du Puy had a butcher shop on Jewett Avenue and Bennett Street (pictured here), while Enos Du Puy's butcher shop was on Port Richmond Square. (Staten Island Historical Society.)

Many merchants, like Albert Nordenholz, brought their wares to customers by horse and wagon. Other food vendors that came by horse, which older residents today still remember, were the iceman, the fishmonger, farmers selling vegetables, and the milkman. The signage for Nordenholz is still visible in a building on the corner of Port Richmond and Castleton Avenues. (Staten Island Historical Society.)

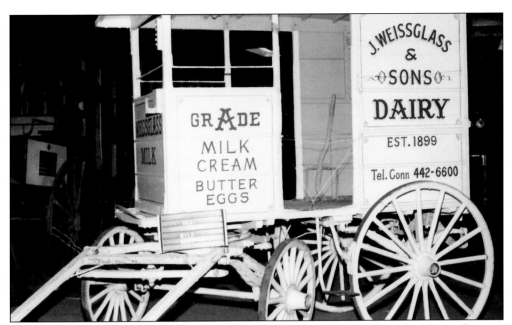

Joseph Meier of Bolechow, Poland, owned a distillery making "white glass." Few know that was the origin of the Weissglass name. Meier's son owned liquor stores in Vienna, Austria. After coming to New York around 1900, Meier's grandson bought a chicken farm on Staten Island. Surplus milk was sold to local Jews on Jersey Street in New Brighton. By 1974, Weissglass milk employed 200 people and operated 30 wholesale trucks. (Staten Island Historical Society.)

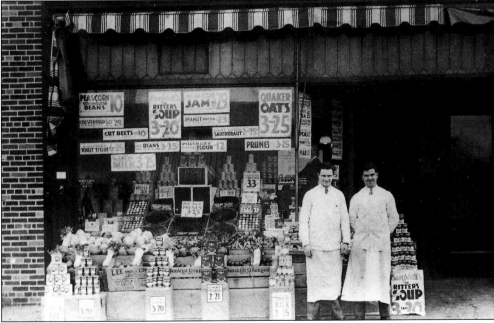

Next to the Ritz Theater, this grocery, one of the 104 shops that Thomas Roulston owned on Staten Island, was managed by a Mr. Devine (left). Thomas Conway Sr. (right) was a store clerk who went on to become a manager for the chain. In an age when three soup cans cost 20¢, they sold sauerkraut, prunes, corn, and other items. (Staten Island Historical Society.)

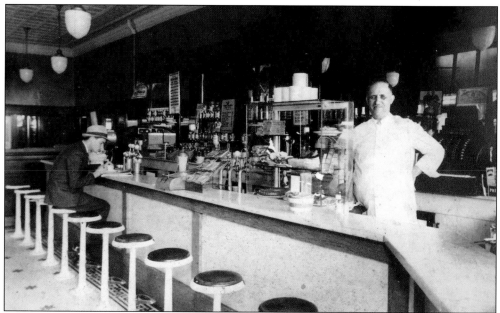

Born in Molaous, Greece, Emmanuel Katsoris went to Chicago in 1901 then moved to New Jersey. To sell produce in Manhattan, he took the Elizabethport Ferry with a horse and wagon and then traveled along Richmond Terrace to the St. George Ferry. A vacant store in Port Richmond Square caught his eye. In 1911, he opened the Port Richmond Square Candy Kitchen, where he sold homemade ice cream and candies. (George and Evangeline Katsoris.)

The ice-cream parlor and nickelodeon drew crowds from local theaters and war workers from nearby shipyards. Sons Peter and George Katsoris sold ice cream on the streets and behind the counter. In 1926, the business relocated from 2064 to 2060 Richmond Terrace, where it remained until Emmanuel's death in 1952. Superior Confections and Supreme Chocolatier, two successful candy businesses, continue to thrive at their South Avenue locations. (George and Evangeline Katsoris.)

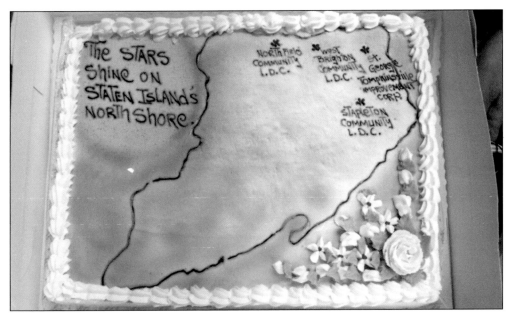

Famous for creating the cake for the wedding scene in *The Godfather*, Oven Bake was established by the Gertz family in 1940. Other notable cakes include a three-dimensional replica of the Lincoln Center and a portrait of Pres. Richard Nixon offered by Philippines president Ferdinand E. Marcos. In addition, Bill and Carl Gertz made unforgettable cakes for many events and anniversaries on Staten Island, including here for the North Shore LDC. (Northfield Community LDC.)

Piazza Bakery, a Port Richmond institution, brought Italian-baked treats to Richmond Avenue. (Northfield Community LDC.)

Homemade ice cream and cherry Cokes were among the delights that Stechmann's offered from its 1936 opening as an ice-cream parlor. Stechmann's was the special hangout of the neighborhood teenagers who made themselves at home in the booths in the back in the 1940s and 1950s. They enjoyed listening to songs from the large jukebox, sitting next to the soda fountain counter, and hanging out beneath the tin roof with square designs. "Where the High School crowd all goes to meet their friends and forget their woes" was the tagline in advertisements. Friday nights were known as basketball nights. Parents were known to call in to find out if their son or daughter was there when they wanted them to come home. Tom Flanagan, the sketch's artist, writes, "Many of my friends met and married through their Stechmann's meetings. It was always good, clean fun. . . . I spent many happy years there." (Tom Flanagan.)

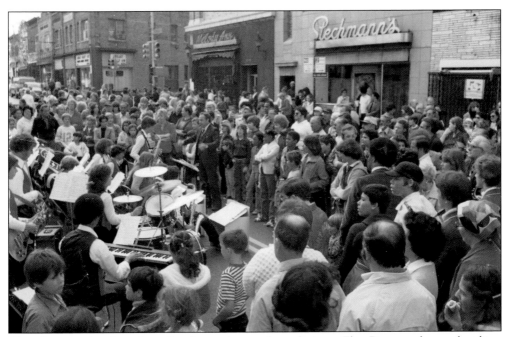

The afternoon lunch trade at Stechmann's, seen here during a Flag Day parade, was bustling. A popular choice was the 35¢ BLT. John Stechmann, the founder, left in 1946 and later set up a new shop in River Edge, New Jersey. Stechmann's closed in 1975. (New York Public Library Archives, Astor, Lenox and Tilden Foundation.)

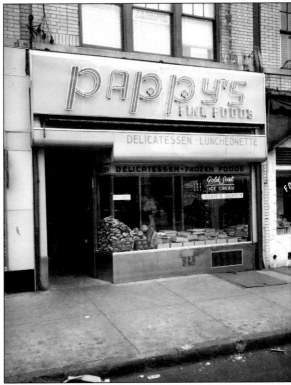

Pappy's, known for its pastrami and pickles, was a Jewish-style delicatessen and luncheonette owned by two Russian men in the 1950s. (Staten Island Historical Society.)

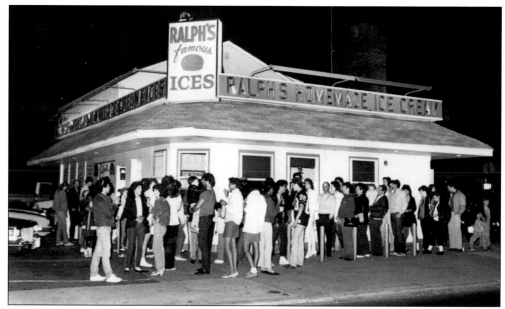

Ralph Silvestro started selling homemade Italian ices and ice cream from a truck in 1928. In 1945, he opened the store Ralph's Homemade Ices on Richmond Avenue. It was a family business, handed down to his daughters Elise Scolaro and Lucille Silvestro. For 80 years, they have made all their ices and ice cream themselves, and they sell it throughout New York City, New Jersey, and Long Island. (*Staten Island Advance*, 1985.)

Safwan, Ahmed, and Mohammed Aziz are seated from left to right. Ahmed built the Food Emporium on Port Richmond Avenue in 1986 and is currently building a restaurant on Forest Avenue. Born in Ibb, Yemen, he arrived in New York in 1967 and on Staten Island in 1980. Behind them stand delicatessen employees Frank "Lucky" Rivera of Hito, Puerto Rico, Katalina (Kathy) Cubelo of Bermeo, Spain (Basque Country), and James "Mumbles" Rinchiuso, whose family came from Naples, Italy. (Lori R. Weintrob.)

In 1937, Carlo Denino opened a restaurant now managed by his grandchildren. Denino's was voted best pizza in New York City. It draws pizza lovers from all over the island and as far away as Australia. One couple from England stops here regularly on their way to the airport. (*Staten Island Advance*, 2003. All Rights Reserved. Reprinted with Permission.)

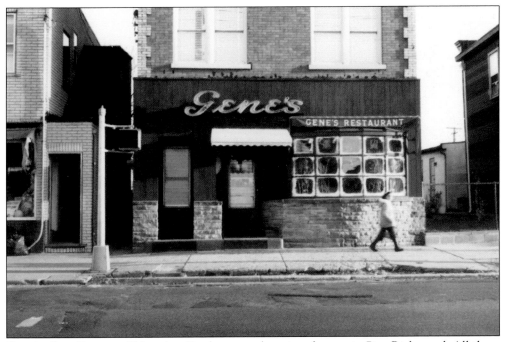

Gene's, Casa Nova, and Venetian Gardens were longtime fixtures in Port Richmond. All three offered Italian dishes. Of the three, only Casa Nova remains. Also gone is the Spa Restaurant on Port Richmond Square, a place for business lunches or an elegant night out. (Northfield Community LDC.)

Filippo and Bart Giove arrived in the United States from Bari, Italy, in 1972. Five years later, they founded Brothers Pizza. In 1982, they moved to 750 Port Richmond Avenue. Their Sicilian pizza won a 2007 *Staten Island Advance* AWE poll. Pictured here are, from left to right, Filippo, his sons Giorgio Giove and Filippo Giove Jr., and Augie Fusco. (Filippo Giove Jr.)

Sal Maker Hussein and his father, Maher Hussein, opened Halal Food and Discount Market in 2001. The store, which features a live poultry market, is visible evidence of the ever-changing ethnic composition of Port Richmond. (*Staten Island Advance*, 2001. All Rights Reserved. Reprinted with Permission.)

Eight

ARCHITECTURE

In 1883, Port Richmond was described as a model village with "well-macadamized streets," "well-paved sidewalks," "trees of large growth," and "substantial" business blocks whose "dwellings range from pretentious mansions to quiet cottages." Large homes along the shore with splendid views of Newark Bay rented for $100 a month. Small homes, including workers' housing, rented for between $25 and $50 a month. Many architectural gems in Second Empire or Gothic Revival style, once owned by doctors and industrial managers, remain along Heberton and Decker Avenues and Bennett Street, thoroughfares named for prominent local residents.

One of Staten Island's leading architects hailed from Port Richmond. The Ritz Theater and Masonic lodge in Port Richmond, as well as the St. George Theater, are to the credit of James W. Whitford Jr., who built nearly 2,000 structures in the New York City region. His father, James Whitford Sr. (1830–1896), orphaned at age 10, first came to Staten Island in 1855 from England to work on building projects such as the boat pavilion at Snug Harbor, Public School 20, and Faith United Methodist Church. Whitford Jr.'s son James III was also an architect. He designed the clock tower on top of the Horrmann Brewery, St. Simon's Episcopal Church, and the Colonial Funeral Home.

Another significant architectural achievement is the Port Richmond branch of the New York Public Library, designed by the firm of Carrère and Hastings. The Forty-second Street branch of the New York Public Library, Staten Island Borough Hall, the Henry Clay Frick Museum, and the city hall in Paterson, New Jersey, are also to its credit. Funds from Andrew Carnegie were used to purchase land from owner Jose T. J. Xiques of Cuba to build a library center adjacent to Port Richmond Park (now Veterans Park), the center of the community.

The Preservation League of Staten Island, the Northfield Community LDC, the Dutch Reformed Church, and the Staten Island Museum have sponsored walking tours to encourage an appreciation of the architecture of this historic neighborhood. It is hoped that this and other chapters in the book will entice readers to follow in the footsteps of the Whitfords, Hebertons, Fabers, Vanderbilts, and others whose homes graced Port Richmond.

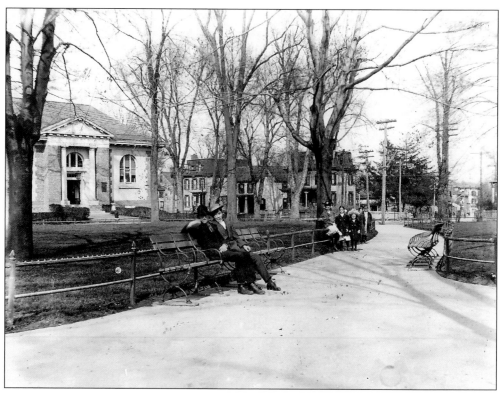

The Port Richmond branch of the New York Public Library at 75 Bennett Street on Veterans Park is a New York City landmark. Architects John Carrère and Thomas Hastings's 1905 design of red brick and stucco features 30-foot-tall ceilings, large, arched windows, and tall pillars at the entrance, "a rural version of classical revival style." Carrère and Hastings was founded in 1885, a year before Carrère moved to St. George. Carrère was born in Rio de Janeiro, Brazil, of Scottish American descent. He met Hastings at the École des Beaux-Arts in Paris. They rose to national prominence by winning the competition for the New York Public Library Forty-second Street branch. The children's reading room was added in 1939, a project of the Works Progress Administration. (Above, Staten Island Historical Society; left, New York Public Library Archives, Astor, Lenox and Tilden Foundation.)

This Victorian Gothic Revival cottage at 121 Heberton Avenue is distinguished by its ornate roof boldly projecting from deep gables and its wraparound veranda. Carpenter James G. Burger, after returning from the California gold rush, built this residence in 1860. In the 1870s, oysterman Capt. John J. Houseman and his wife, Jane Vreeland, lived here. An ardent abolitionist, Houseman provided ships for Union soldiers during the Civil War. Notable residents included Emil Bottger, superintendent of public schools from 1888 to 1892, and Robert Brown, chief of the Democratic County Committee in the 1920s. In the image below, the 1891 Romanesque Revival design of Public School 20 and its 1898 addition, with eight rounded arches, a lofty bell tower, and a clock, projects civic pride. After a period of decay, it was converted to Parkside Senior Housing by Northfield Community LDC in 1993. Both sites are landmarked. (Right, Lori R. Weintrob; below, Staten Island Historical Society.)

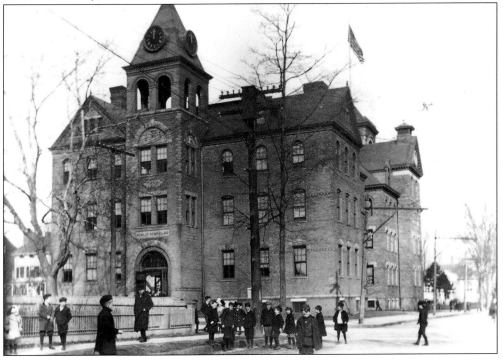

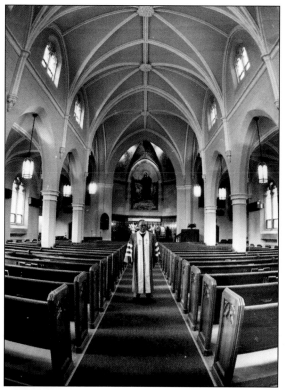

The 1850 Gothic Revival cottage at 93 Park Avenue below features a steep slate roof, pointed dormers, elaborate cutwork on the bargeboards covering the eaves, windows with label cornices, and carved woodwork. Lot C. Clark was the prosecuting attorney for the murder trial of Polly Bodine, one of the most sensational trials in 19th-century America. Bodine was accused of murdering her sister-in-law and niece. Due to publicity, the venue for the trial was changed several times. She was acquitted, and the crime remains unsolved to this day. Later Clark's home housed DeGroot, Rawson, and Safford law firm and then the Port Richmond Day Nursery. Also next to Veterans Park, the St. Philip's Baptist Church boasts a stunning interior architecture with Gothic vaulted arches. (Left, *Staten Island Advance*, 1991. All Rights Reserved. Reprinted with Permission; below, Staten Island Historical Society.)

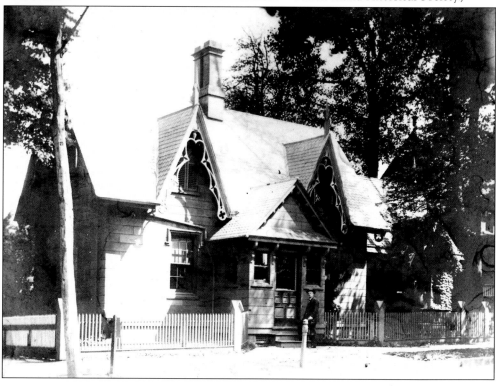

This 154-year-old house at 29 Cottage Place was a stagecoach stop. The home has been restored and decorated with tin ceilings and unique furnishings, including a 1936 bulb-top refrigerator. The fence is a copy of the Belcher-Ogden house fence (around 1697) in Elizabeth, New Jersey, that owner John Foxell admired. (John Foxell.)

Although the elegant homes in Colonial Revival or Second Empire style along Heberton Avenue attracted the managers and professionals, including doctors, who gave it the name of "Doctor's Row," closer to Richmond Terrace, more modest homes were built for workers. Similar homes were built in Stapleton for factory workers there. (Lori R. Weintrob.)

Across Castleton Avenue from Faith United Methodist Church at 233 Heberton Avenue stands this 1860s Italianate villa. Distinguished by its tall, square central tower and low (nearly flat) hip roof, this five-bay house was occupied by Dr. T. D. Lyon in 1874. This house was restored recently by Steve Ruggirello, a former firefighter, who added a display honoring victims of 9/11. Note the dramatic overhang and eaves supported by brackets. (Lori R. Weintrob.)

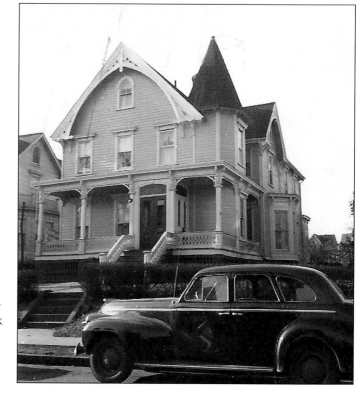

At 253 Heberton Avenue, a large home built in the 1890s is one of Port Richmond's many Queen Anne–style houses. It features a corner tower, bay windows, elaborate cutwork bargeboard, porch railing, and beautiful stained-glass windows. (Staten Island Historical Society.)

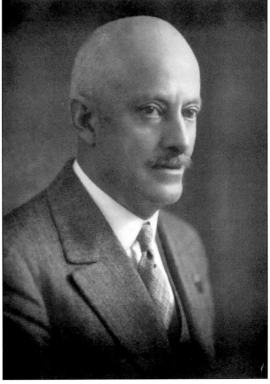

This grand Greek Revival building with a large portico at 120 Anderson Avenue, designed and built by James W. Whitford Jr. (pictured), was dedicated as a Masonic temple in 1926. The headquarters for an army antiaircraft unit was based here during World War II. In 1944, the CYO opened here. Whitford (born in 1871) has been called "Staten Island's leading architect." He designed and built about 2,000 structures, including the 120th New York Police Department Precinct Stationhouse and the Ritz and St. George Theaters. His father, James Whitford Sr., came to Staten Island in 1855 and had an office in Port Richmond, where he also served as an organist for three decades at Park Baptist Church. James Sr. is best remembered as an architect of the Victorian-style village hall in New Brighton and Grace Methodist Episcopal Church, while working with George Smalle. (Above, Staten Island Historical Society; right, James W. Whitford IV.)

Behind a playful James Smith stands Temple Emanu-El, a classical revival building constructed on Post Avenue in 1907 by Port Richmond architect and engineer Harry W. Pelcher. With its tall portico and prominent dome mounted on an octagonal drum, the temple and the stairs leading to its entrance bring grandeur to the street. The interior features an ark that echoes the exterior design. Smith is now a trustee of the temple. (James Smith.)

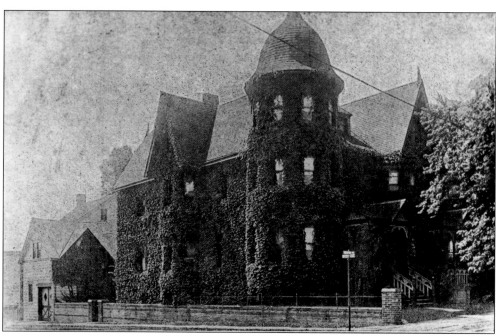

On the corner of Richmond and Post Avenues, the former Charles E. Griffith residence can be seen. It was the law office of the Braisted family until 2004. Griffith also had a building on Port Richmond Square where he sold leather goods in the late 1800s that still stands across from the Dutch Reformed church and cemetery near the old Empire Theater. It is worth walking from the Griffith residence through the heart of the old Richmond Avenue business district to Port Richmond Square. (Staten Island Historical Society.)

Nine

EDUCATION

With over 200 graduates each year since 1927, many Staten Islanders have passed through the doors of Port Richmond High School, singing these words composed by George H. Eggers: "These are the fields we played on / These are the halls we trod, / Where we met each test / With our very best / And we placed our faith in God. / This is the school we strove for / Holding its banner high, / And through all the days / Of our lives we'll praise / Port Richmond High."

At graduation, students pledged, "As a citizen, to work both alone and with many, to improve my city; and as an American, to obey my country's laws and to support and defend its Constitution." Competition was focused in the classroom, which included home economics and industrial arts, and on the athletic fields. In February 1971, racial tensions led Port Richmond High School students to boycott classes, leading to the development of a black studies program.

While private schooling existed in Port Richmond as early as the American Revolution, free public education was mandated in New York State in 1842 with the establishment of the public school system. Staten Island's 18 one-room schoolhouses featured arithmetic, penmanship, geography, reading, spelling, dictation, and singing. Northfield Township District School No. 6 was located at the corner of Heberton Avenue and Elizabeth Street (present-day New Street), which later became Public School 20. Residents were also served by Port Richmond Day Nursery, or Public School 21 on Sherman Avenue, as well as Public School 22 on Forest Avenue in Graniteville.

Across Veterans Park from Public School 20, the Port Richmond library was constructed in 1905 using a gift from Andrew Carnegie, the famous industrialist, to educate both children and adults. It was the second library on Staten Island after the Tottenville branch. The foreign language collections, English as a second language (ESL) classes, and performances held there, including Norwegian plays and black poetry readings, responded to the needs of the community's changing ethnic composition.

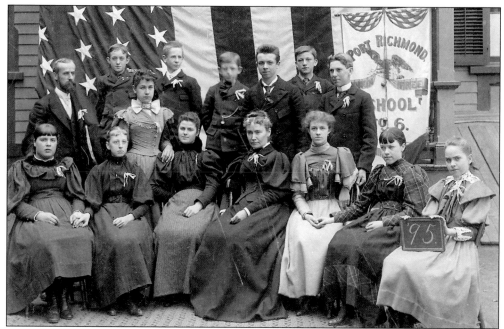

As early as 1881, students could take high school courses at the Union Free School in Port Richmond. From 1904 to 1927, students had to travel to Curtis High School, until a burgeoning population on the north shore necessitated the construction of Port Richmond High School. (Staten Island Historical Society.)

The Port Richmond Day Nursery and Central Relief Fund, founded in 1895, provided low-cost day care for working mothers. At Christmas, they gave out turkeys, mittens, and toys. In 1916, 93 Park Avenue was bequeathed to the nursery. In 1954, it moved into Mariners Harbor low-income housing projects and merged with Staten Island Mental Health. In this image, Larry Ambrosino (standing), who enjoyed puppet shows and shepherd's pie as a preschooler there, was invited back. (Ken Popler.)

Here is the Public School 20 kindergarten class. Note the three ferries among the art projects. The young African American child in the rear was one of two in the class of 35. Aldo Merlino is seated third from the right wearing a sailor's suit. After serving in the military and then working at Bethlehem Steel, he retired to become a special education teacher on Staten Island. (Ann Merlino.)

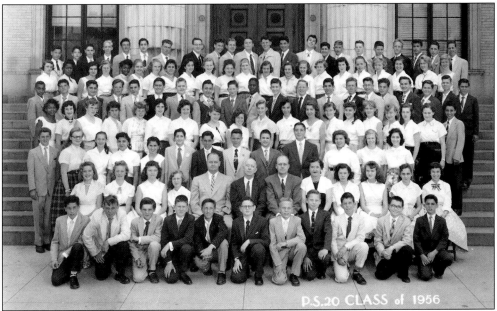

The youngest Merlino child, Robert, graduated from Public School 20 in 1956; he is seen in the third row, fourth from the right. He owned an antique brass store on Port Richmond Avenue from 1982 to 2005. His love of antique automobiles and his skills as a silversmith led to an international business. His work can be seen in churches, schools, and houses throughout Staten Island. (Ann Merlino.)

Enjoying the Port Richmond High School senior prom in 1956 are Ann Merlino and her friends. The young women reunited in 1981 and 1986 for their 25th and 30th high school reunions. Merlino, who became chairperson of the biology department and dean at the College of Staten Island, was appointed to the mayor's Commission on the Status of Women. (Ann Merlino.)

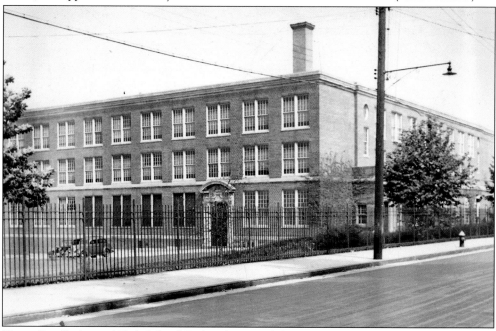

Here is Port Richmond High School. Before the consolidation of New York City in 1898, a two-year high school program had existed in Port Richmond, but it was transferred to Curtis High School when it opened in 1904 and later relocated to Curtis High School Annex in Public School 20. In 1927, Port Richmond High School opened for 1,200 pupils. (Evelyn Otten McDonald.)

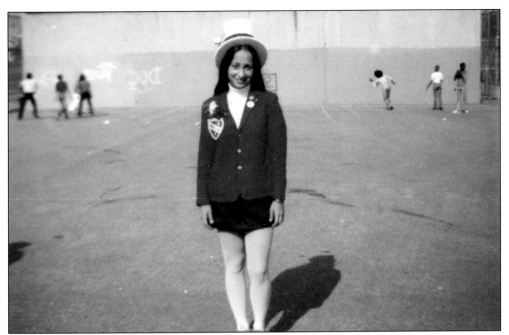

Cheryl Criaris, a member of the Belle Brummells at Port Richmond High School, participated in the annual Psych It Up Red Day celebration. The Belle Brummells participated in homecoming and other parades. Criaris followed the path of many Port Richmond graduates by attending Wagner College where she majored in nursing. (Cheryl Criaris Bontales.)

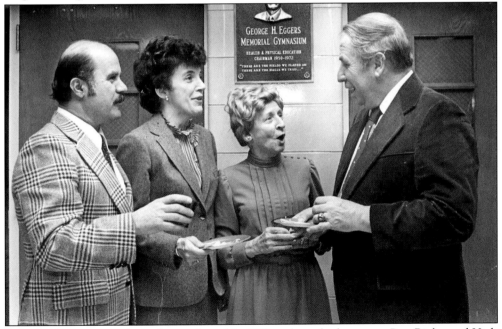

Bob Matthews, pictured at right, graduated in 1948 and coached sports at Port Richmond High School for decades. He remains active in the Port Richmond Alumni Association, which he presided over from 1994 to 2001. (*Staten Island Advance*, 1983. All Rights Reserved. Reprinted with Permission.)

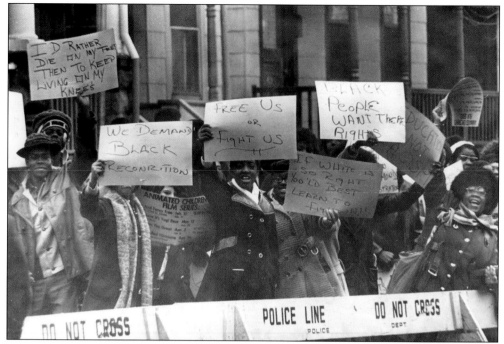

In 1971, African American students demanded more black studies classes and attempted to fly the black liberation flag in the cafeteria. The resulting tension led to conflict within the school and with police. (*Staten Island Advance*, 1971. All Rights Reserved. Reprinted with Permission.)

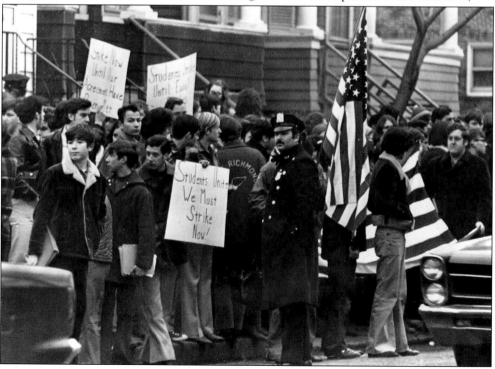

In January 1943, the Port Richmond library hosted an exhibit of Norwegian paintings and crafts called Norway Lives! The exhibit's program included a keynote speech from the president of the Norwegian parliament in exile and traditional Norwegian songs performed by the Norsemen Glee Club and children from the library's Norwegian classes. (New York Public Library Archives, Astor, Lenox and Tilden Foundation.)

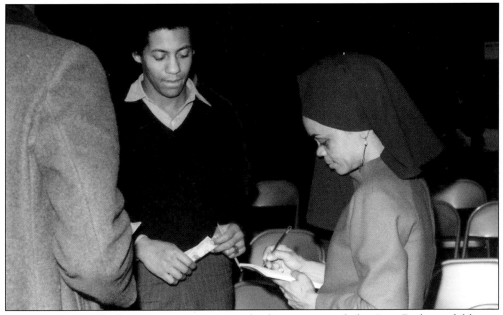

In 1972, Sonia Sanchez, a poet, activist, and educator, visited the Port Richmond library. Her third book, *Liberation Poem* (1970), had just been published; since then she has written dozens of plays and books. An admirer of Malcolm X, she joined the Nation of Islam in 1971 but left in 1976 due to misogyny. (New York Public Library Archives, Astor, Lenox and Tilden Foundation.)

The 100th anniversary of the Port Richmond library featured author Paul Zindel (far left). He was joined by Andrew Wilson, digital producer of the New York Public Library; Frederick Osmer, the great-nephew of the first man to check out a book at this branch; and New York State assemblywoman Elizabeth A. Connelly. (New York Public Library Archives, Astor, Lenox and Tilden Foundation.)

The corner of Heberton Avenue and New Street was officially renamed for Helen Kaufman, who served as crossing guard for children going to Public School 20 beginning in 1957. Her starting salary was $1.25 an hour. She was required to use the call box with a telephone to check in with the police department three times a day. A 1936 graduate of Port Richmond High School, she attended Zion Lutheran Church with her Norwegian-born parents. (Helen Kaufman.)

Ten

MILITARY

Port Richmond residents have contributed to all major American conflicts, whether by serving in the armed forces or by doing their part on the home front to support the troops.

Although many Staten Islanders were Loyalists during the American Revolution, the Mersereaus of Port Richmond (then known as Decker's Ferry) were the island's leading patriot family. Partisan warfare and the occupation by British forces brought much suffering to Port Richmond. The Dutch Reformed church, associated with the patriot cause, was plundered by the British and their Hessian allies and requisitioned for use as barracks and stables. The town was twice attacked by patriots, once during Gen John Sullivan's raid in 1777 and again at Stirling's raid in 1780.

During the Civil War, the Port Richmond area was the site of Camps Decker, Low, and Ward. Recruiters at Port Richmond's Oriental Hall offered volunteers a $50 bounty for enlisting in the Union army. In July 1863, draft riots broke out in Manhattan. The violence eventually spread to Staten Island. Port Richmond residents placed a small cannon at the bridge where the Shore Road crossed Bodine's Creek (present-day Richmond Terrace and Jewett Avenue), preventing rioters from entering the village. Moreover, Port Richmond resident Chief John Decker of New York's volunteer fire department gallantly defended the Colored Orphan Asylum in Manhattan.

Port Richmond's servicemen and servicewomen fought bravely during the two world wars, while its civilians did their parts on the home front, buying liberty bonds, raising money for refugee relief, planting victory gardens, serving in the civil defense, coping with wartime rationing, volunteering for the USO, and working in hospitals, shipyards, and munitions and aircraft factories.

Uranium stored in a warehouse under the Bayonne Bridge helped usher in the atomic age. The 1950s and 1960s brought the cold war and American military efforts to prevent the spread of communism. Port Richmond residents answered the call of duty and served in the Korean War and the Vietnam War.

A number of Port Richmond residents were killed in the terrorist attacks of September 11, 2001. Soon after, some residents joined the armed forces to serve in military operations in Iraq and Afghanistan.

Brothers Joshua, John, and Jacob Mersereau, and Joshua's son John La Grange Mersereau were key operatives in the Dayton-Mersereau-Hendricks spy ring that secured vital information for Gen. George Washington on the strength of British forces, troop deployments, and invasion plans. Operating from behind British lines on Staten Island and in parts of New Jersey, the Mersereaus and their informants were highly effective until the end of the war. A plaque at the Reformed church honors these and two other brothers who served in the Revolutionary War. (Lori R. Weintrob.)

On August 22, 1777, patriot troops commanded by Gen. John Sullivan raided Staten Island. Several skirmishes were fought in the Port Richmond area between the patriots and British and Loyalist forces. This stone monument was erected in 1930 in Veterans Park by the Daughters of the American Revolution. (*Staten Island Advance*, 2002. All Rights Reserved. Reprinted with Permission.)

Capt. David M. Stothers was a recruiter for the 4th Regiment, New York State Volunteers, Empire Brigade, in Port Richmond. In August 1862, he enlisted many men for the Union army, including boatman Prier Van Pelt. Although Van Pelt was a Staten Island native, other recruits were born in Ireland, Germany, and France and held occupations such as boilermakers, carpenters, and farmers. (Staten Island Historical Society.)

A large stone monument stands today in Egbert Triangle, located at Port Richmond and Forest Avenues. Dedicated by American Legion Post No. 95, it commemorates the service of Seaman 2nd Class Arthur S. Egbert and other Port Richmond–area residents who died in World War I. Egbert, a member of a prominent Staten Island family, perished aboard the USS *President Lincoln* when it was sunk on May 31, 1918. (Lori R. Weintrob.)

Coxswain Merton Stellenwerf of the U.S. Coast Guard was posthumously awarded the Navy Cross for heroism. He was among 18 volunteers from the U.S. Coast Guard cutter *Seneca* who tried to keep the British steamer *Wellington* afloat after it was torpedoed in the Bay of Biscay in September 1918. Eleven of the volunteers, including Stellenwerf, perished when the ship sank. A plaque was erected on Gibraltar to their memory. (Staten Island Historical Society.)

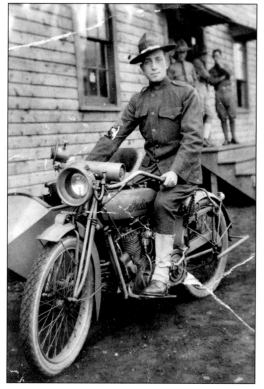

Gioacchino Merlino enlisted in the U.S. Army in 1918, but a heart condition prevented him from serving overseas. His daughters recall that a Jewish doctor at the hospital in Camp Dix, New Jersey, befriended this young Italian immigrant and taught him photography, which evolved into a lifelong career. Army officials changed his first name to John. His two sons were in the U.S. Army Signal Corps: Rudy served in Germany during World War II, and Aldo was stateside during the Korean War. (Ann Merlino.)

After graduating from Public School 21, William Di Stephano worked as a carriage painter for the Standard Varnish Works in Elm Park. An accomplished flutist with the Castellucci Band, he set aside his musical career when he was drafted. During World War I, Di Stephano served with the U.S. Army's 32nd Division and experienced the hardships of trench warfare in France. (Rocco and Joan Speranza.)

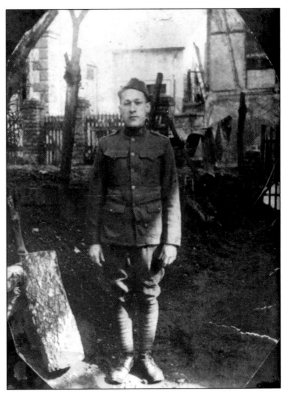

Seen from left to right, Harry, George, and William Criaris saw action during World War II. George served in the U.S. Navy, and Harry and William were in the U.S. Army. The latter two were drafted on the same day in March 1941. William was a chief warrant officer in Gen. George Patton's 5th Armored Division and fought in North Africa and Italy. Another brother, Evangelos, served in the Korean War. (Cheryl Criaris Bontales.)

James McKee (left) grew up on Hatfield Place. After serving in World War II, he became a career navy officer. He is seated next to his brother Samuel and sister-in-law Dorothy Scholl McKee (Barbara McKee Niler.)

William Morris Jr., of Faith United Methodist Church, served in the 369th Coast Artillery, an all-black regiment known as the "Harlem Hellfighters." He saw combat at Omaha Beach on D-day and at the Battle of the Bulge. In Georgia, while training African American troops, he encountered racism. Morris's father, who owned a moving company, founded the Staten Island Chapter of the National Association for the Advancement of Colored People (NAACP) in 1925. (William Morris Jr.)

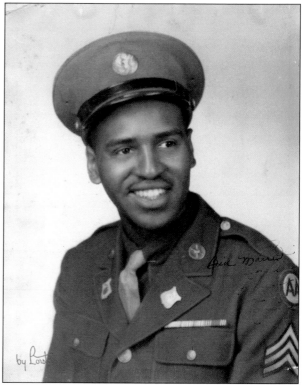

Lt. Emanuel Josephson was one of six Jewish war veterans from Temple Emanu-El who perished in World War II. Melvin Amtzis, Otis Danneman, Boris Lifshitz, Nathan Polsky, and Tobias Reich all died fighting against Nazism and the persecution of Jews during the Holocaust. (Temple Emanu-El.)

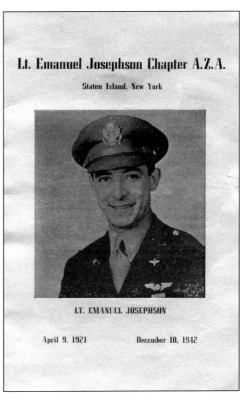

Lt. Emanuel Josephson Chapter A.Z.A.

Staten Island, New York

LT. EMANUEL JOSEPHSON

April 9, 1921 December 18, 1942

Bernard Krebs served in the U.S. Army Air Corps during World War II in the China-Burma-India theater. After the war, he worked as a longshoreman for the Baltimore and Ohio Railroad in St. George. (Edward Pedersen.)

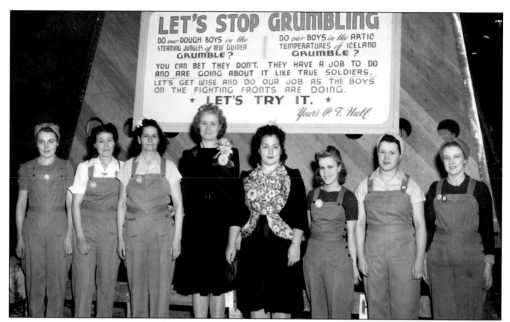

Helen Zazakos, seen at center right in this 1943 photograph, was one of many female Port Richmond residents who worked at the naval division of the Electric Launch Company (or Elco) in Bayonne, New Jersey. During World War II, millions of women entered the workforce. The popular song "Rosie the Riveter" urged women to work for victory and gave birth to an iconic pop culture figure. (Cheryl Criaris Bontales.)

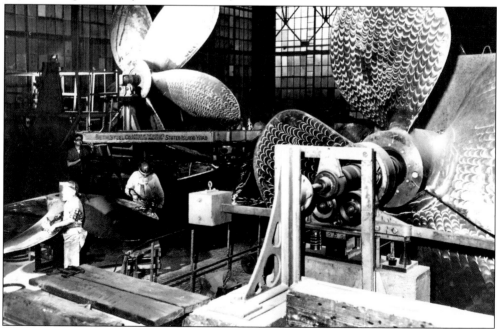

The Bethlehem Steel shipyard in Mariners Harbor opened in the 1930s. It featured a foundry specializing in propeller production for the 14 other Bethlehem Steel shipbuilding sites around the country. During World War II, the shipyard employed many Port Richmond residents, both men and women, and operated 24 hours a day. (Staten Island Historical Society.)

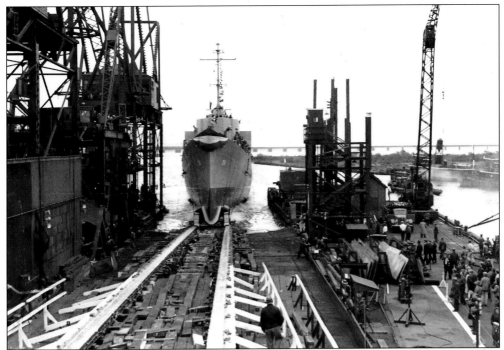

The destroyer USS *Frank E. Evans* (DD-754) was one of several naval vessels built at the Bethlehem Steel shipyard in Mariners Harbor during World War II. It was launched on October 3, 1944, and saw action in the Pacific theater. The *Frank E. Evans* also served in the Korean and Vietnam Wars, but on June 3, 1969, it was cut in half in a collision in the South China Sea. (Staten Island Historical Society.)

World War II changed everyday life in America. Cotton, silk, gasoline, rubber, leather, paper, produce, meats, and items made of metal were strictly rationed by the government. Families recycled and grew victory gardens in their yards to support the war effort. Marjorie Decker Johnson is seen here starting what became a 20-foot-by-20-foot victory garden of carrots, beets, corn, pumpkins, potatoes, and more. (Marjorie Decker Johnson.)

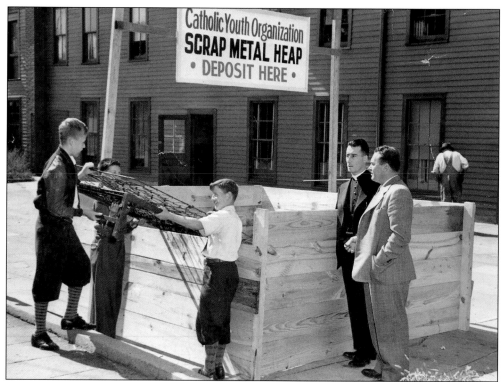

Pres. Franklin D. Roosevelt's radio addresses called upon Americans to do something every day to serve their country, recalls Port Richmond native Robert Anderson, who served in World War II and now teaches history at Wagner College. Like the young people in this photograph, Anderson went around the neighborhood with a cart collecting aluminum and other scrap metals used to manufacture armaments. His working-class family saved its money to buy war savings stamps and war bonds. (Catholic Youth Organization.)

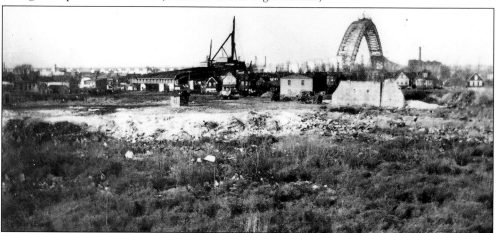

The Manhattan Project stored more than 4,000 drums of uranium from the Belgian Congo for the atomic bomb in a warehouse that was owned by the Archer-Daniels-Midland Company on Richmond Terrace near the Bayonne Bridge. The warehouse was torn down in 1976. America's use of the atomic bomb in August 1945 to hasten Japan's surrender launched the nuclear age and the cold war. (Staten Island Historical Society.)

Rocco Speranza was drafted into the U.S. Army in May 1945. In Japan, he witnessed the impact of the atomic bomb. Then on June 25, 1950, the Soviet-backed communist forces of North Korea launched an invasion across the 38th parallel. From 1951 to 1952, Speranza served in the Korean War, in which 140,000 Americans were killed or wounded. Today he belongs to the Veterans of Foreign Wars, the American Legion, and the Korean War Veterans Association. (Rocco and Joan Speranza.)

A 1947 graduate of Port Richmond High School, Lou Tirone was drafted into the U.S. Army in 1950. He is seen here at a training camp in Hokaido, Japan. He served in the Korean War, where he and his fellow servicemen endured bitter combat and frigid weather, with temperatures sometimes plunging to 35 degrees below zero. During combat, his feet froze, and he spent two weeks in the hospital. Tirone is proud of his service in Korea because "we stopped communism." He often visits Staten Island schools, educating students about the "Forgotten War." (Lou Tirone.)

Lance Cpl. Nicholas Papas, pictured here with his father, Phillip, attended Port Richmond High School and enlisted in the U.S. Marine Corps in 1961. He served in the Vietnam War at Da Nang with the 8th Engineer Battalion from 1965 to 1966 and was awarded the Purple Heart for wounds received in combat. (Nicholas and Elisabeth Papas.)

Nurse Mary Lamanna, at age 20, was stationed at 3rd field hospital in Saigon in 1970. The hospital was across from the American embassy, which had been under siege during the 1968 Tet Offensive. Lamanna received her bachelor's and master's degrees from the nursing department at Wagner College. During her 40-year career, she served as manager at St. Vincent's Hospital. She is active in Vietnam Veterans of America, Thomas J. Tori Chapter of Port Richmond. (Mary Lamanna.)

Gunner's Mate James (Jimmy) R. Wright served two tours of duty in the Vietnam War from 1969 to 1971. He served aboard the attack cargo ship USS *Washbourne* and the flagship USS *El Dorado*. His father, a World War II veteran, was half Irish and half Cherokee Indian. In the movie *Freedomland*, filmed on Staten Island, he had a minor role in the search party for a missing child. He is active in Vietnam Veterans of America, Thomas J. Tori Chapter. (James R. Wright.)

Port Richmond resident Sgt. Richard J. Carreras served from 2004 to 2005 in Operation Iraqi Freedom at Camps Taji and Cooke in Iraq, where he went on patrol, guarded prisoners, and protected Iraqi voters, interpreters, and base workers. Although a member of the 42nd Division of the 101st Cavalry, Carreras was attached to the 69th Infantry Division. (Richard J. Carreras.)

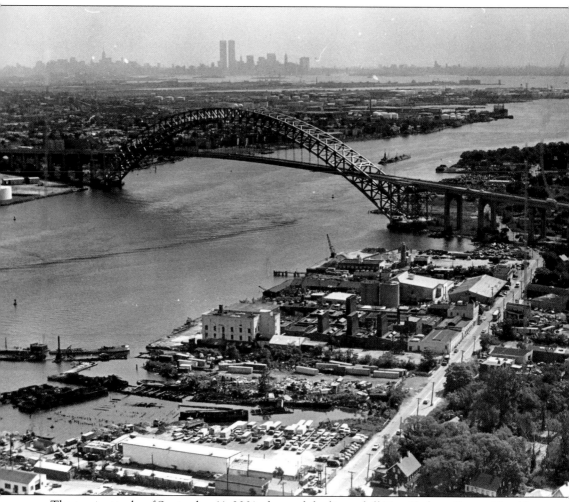

The tragic attacks of September 11, 2001, changed the lives of all New Yorkers. Staten Island lost 267 firefighters, policemen, and other residents. The deaths of the following from Port Richmond are mourned: Chief Joseph Grzelak, Fire Department of the City of New York (FDNY) Battalion 48, Brooklyn; firefighter David LaForge, FDNY Ladder 20, Manhattan; Susan Clancy Conlon, Bank of America; Rosa Maria Feliciano, Marsh and McLennan; and Troy Nilsen, Cantor Fitzgerald. Also mourned are firefighter George DiPasquale, FDNY Ladder 2, Manhattan, of Elm Park, as well as Philip Ognibene from Keefe Bruyette and Woods and Barbara Etzold from Fred Alger Management, former residents of the Port Richmond area. (*Staten Island Advance*, 1984. All Rights Reserved. Reprinted with Permission.)

BIBLIOGRAPHY

Cudahy, Brian J. *Over and Back: The History of Ferryboats in New York Harbor.* New York: Fordham University Press, 1990.

Dickenson, Richard. *Holden's Staten Island: A History of Richmond County.* New York: Center for Migration Studies, 2002.

Hine, Charles G., and William T. Davis. *Legends, Stories and Folklore of Old Staten Island.* Part I, *North Shore.* Staten Island, NY: Staten Island Historical Society, 1925.

Hughes, Langston. *The Big Sea.* 1940.

Kimmerer, Gladys, ed. *A Story of Faith: A History of Faith United Methodist Church.* 1976.

Leng, Charles W., and William T. Davis. *Staten Island and Its People, A History: 1609–1929.* New York: Lewis Publishing Company, 1930.

Overton, Cleve. *In the Shadow of the Statue of Liberty: A Memoir of a Black American.* Washington, D.C.: Diaspora Voices Press, 2006.

Papas, Phillip. *That Ever Loyal Island: Staten Island and the American Revolution.* New York: New York University, 2007.

Renehan, Edward J., Jr. *Commodore: The Life of Cornelius Vanderbilt.* New York: Basic Books, 2007.

Salmon, Patricia. *Realms of History: The Cemeteries of Staten Island.* New York: Staten Island Museum, 2006.

Shepherd, Barnett. National Register of Historic Places Registration Form: Temple Emanu-El, 2006.

Weissglass, Charles. *Smiling Over Spilt Milk: A Family History.* 1984.

Wilson, Andrew. "The Port Richmond Branch Library, The First 50 Years: 1905–1955." www.nypl.org. Originally published in *Staten Island Historian,* New Series 2, 19 (Winter–Spring 2002).

Zavin, Shirley, and Elsa Gilbertson. *Staten Island Walking Tours.* Staten Island, NY: Preservation League of Staten Island, 1986.

DISCOVER THOUSANDS OF LOCAL HISTORY BOOKS
FEATURING MILLIONS OF VINTAGE IMAGES

Arcadia Publishing, the leading local history publisher in the United States, is committed to making history accessible and meaningful through publishing books that celebrate and preserve the heritage of America's people and places.

Find more books like this at
www.arcadiapublishing.com

Search for your hometown history, your old stomping grounds, and even your favorite sports team.

Consistent with our mission to preserve history on a local level, this book was printed in South Carolina on American-made paper and manufactured entirely in the United States. Products carrying the accredited Forest Stewardship Council (FSC) label are printed on 100 percent FSC-certified paper.

MADE IN THE
USA